MW00776560

DAVID BOWIE
LIVE IN NEW YORK

PHOTOGRAPHS BY MYRIAM SANTOS-KAYDA
WITH A FOREWORD BY DAVID BOWIE

powerHouse Books
NEW YORK, NY

DAVID BOWIE
LIVE IN NEW YORK

© 2003 POWERHOUSE CULTURAL ENTERTAINMENT, INC.
PHOTOGRAPHS © 2003 MYRIAM SANTOS-KAYDA
FOREWORD © 2003 DAVID BOWIE

ALL RIGHTS RESERVED. NO PART OF THIS BOOK MAY BE REPRODUCED IN ANY MANNER IN ANY MEDIA, OR TRANSMITTED BY ANY MEANS WHATSOEVER, ELECTRONIC OR MECHANICAL (INCLUDING PHOTOCOPY, FILM OR VIDEO RECORDING, INTERNET POSTING, OR ANY OTHER INFORMATION STORAGE AND RETRIEVAL SYSTEM) WITHOUT THE PRIOR WRITTEN PERMISSION OF THE PUBLISHER.

PUBLISHED IN THE UNITED STATES BY POWERHOUSE BOOKS,
A DIVISION OF POWERHOUSE CULTURAL ENTERTAINMENT, INC.
68 CHARLTON STREET, NEW YORK, NY 10014-4601
TELEPHONE 212 604 9074, FAX 212 366 5247
E-MAIL: DAVIDBOWIE@POWERHOUSEBOOKS.COM
WEB SITE: WWW.POWERHOUSEBOOKS.COM

FIRST EDITION, 2003

LIBRARY OF CONGRESS CATALOGING-IN-PUBLICATION DATA:

SANTOS-KAYDA, MYRIAM.
 DAVID BOWIE : LIVE IN NEW YORK / PHOTOGRAPHS BY MYRIAM SANTOS-KAYDA.
 P. CM.
 ISBN 1-57687-181-9
 1. BOWIE, DAVID--PORTRAITS. 2. ROCK MUSICIANS--ENGLAND--PORTRAITS. 3. ROCK
CONCERTS--NEW YORK (STATE)--NEW YORK--PICTORIAL WORKS. I. TITLE.

 ML88.B67S36 2003
 782.42166'092--DC21
 [B]
 2003046704

HARDCOVER ISBN 1-57687-181-9

SEPARATIONS, PRINTING, AND BINDING BY ARTEGRAFICA, VERONA

A COMPLETE CATALOG OF POWERHOUSE BOOKS AND LIMITED EDITIONS IS AVAILABLE UPON REQUEST;
PLEASE CALL, WRITE, OR WHAM BAM OUR WEB SITE.

10 9 8 7 6 5 4 3 2 1

PRINTED AND BOUND IN ITALY

BOOK DESIGN BY REX RAY

FOR ETHAN

LIVE IN NEW YORK
BY DAVID BOWIE

The year's touring was at an end. We'd finished the way we started, on a high, at the Carling Apollo, Hammersmith in London on October 2, 2002. It was all meant to stop right there, but. . . Looking at the October schedule, it was clear we had a number of New York TV commitments at hand, so I needed to keep the band together for another couple of weeks before they drifted off to family and friends for the winter.

Yet, I didn't want us to drift too far from New York itself and end up charging around Ohio or wherever, pulling gigs out of a hat. It was Bill, a friend, who came up with the initial idea of keeping us in New York. At first, we surmised we could do just clubs in Manhattan or, maybe, how about a residency at someplace like the Mercury Lounge?

"You know something?" Bill asked, "Wouldn't it be cool to follow the marathon route? It crosses all five boroughs, keeping within the confines of New York itself." The idea couldn't be bettered. We booked up and formed a loose definition that all the gigs should be club size.

The short straw went to Staten Island as first gig, Earl Slick country. Earl was freaked and excited at the same time. "Oh, God, I'm gonna see some really old faces," he said. "We're gonna get Joey Bag-a-Doughnuts, Rat, all of 'em. Frankie La Rocka, 'Beau' Jack. And then there's family. I'm never gonna survive this."

We arrived and set up at the very intimate Music Hall at Snug Harbor, a wonderfully atmospheric little theater. There were eight of us in all and once the equipment was beside us, the stage area became postage-stamp sized. But this didn't quench any of our enthusiasm. I think we played for one hour thirty or even more.

Just as with the year's tour, I tried to dip into every period, from "Ziggy" to "Heathen." It's so hard to settle on a set list that will appeal to everyone; there's always someone who will moan that such and such a song was left out, but when you've made as many albums as I have that's inevitable. I just go with what I want to do and that's that. Some nights I'd throw in "Moonage Daydream," another night "White Light." Or maybe "Bewlay Brothers," "Look Back in Anger," or "Be My Wife."

WE ARE ALWAYS SO THRILLED AT THE RECEPTION THAT SONGS LIKE "I'M AFRAID OF AMERICANS" AND "HALLO SPACEBOY" RECEIVE, AS THEY ARE NOT MY BEST KNOWN BUT HAVE TAKEN ON A NEW KIND OF POWER OVER THE YEARS. IT'S OFTEN BEMUSED ME THAT SONGS WHICH NEVER MADE THE TOP 40 HAPPEN TO BE MY AUDIENCES' FAVORITES, BE IT "HEROES" OR "CHANGES" OR SUCHLIKE. IT'S A GOOD FEELING TO KNOW THAT MY FANS HAVE ALWAYS LISTENED TO THE ALBUMS A GREAT DEAL AND ARE NOT A SINGLES KIND OF GROUP.

ON SUCH A WHIRLWIND OF A TOUR, IT WAS DELIGHTFUL TO TAKE IN THE PERSONALITY OF EACH GIG. ON THE MAJOR CIRCUIT, EVERYTHING LOOKS MUCH THE SAME—BIG BARREN ARENAS DON'T HAVE MUCH OF A VIBE. BUT IN THE NEW YORK BOROUGHS, WELL, IT'S A DIFFERENT KETTLE OF *POISSON*! AT COLDEN CENTER AT QUEENS COLLEGE, MY BAND SAID THEY FELT LIKE THEY WERE BACK IN HIGH SCHOOL. AT JIMMY'S BRONX CAFE, WE ATE WHAT WAS POSSIBLY THE BEST FOOD ALL TOUR. HOT AND SPICY AND TONS OF IT. THIS PLACE WAS REPLETE WITH DANCE FLOOR AND, YES, A DISCO BALL. TOO BEAUTIFUL FOR WORDS. AND WE USED IT, OF COURSE. CAT, (OR CATHERINE RUSSELL, OUR NEW SINGER, KEYBOARDIST, AND CONGA PLAYER) IS OUR LOCAL GIRL HERE. THEN THERE'S ST. ANN'S WAREHOUSE IN DEEPEST ARTY DUMBO (IN BROOKLYN, FOLKS, AN ACRONYM FOR DOWN UNDER THE MANHATTAN BRIDGE OVERPASS).

WE ENDED UP AT THE BEACON THEATER IN MANHATTAN. I'VE SEEN SO MANY SHOWS THERE, FROM LAURIE ANDERSON TO GRANDADDY, IT SEEMED JUST RIGHT TO FINISH THIS LEG OF THE TOUR AT SUCH A RENOWNED SPOT. WHEN GAIL ANN AND I SLOW DANCED THROUGH "ABSOLUTE BEGINNERS" THAT NIGHT, WE BOTH FELT JUST THAT. IT DIDN'T SEEM LIKE THE END OF A LONG AND GRUELING YEAR, BUT A NEW TIME WITH A HORIZON THAT WENT ON FOREVER. AS WE LEFT THE STAGE THAT NIGHT TO THE SOUND OF GERRY'S LAST GUITAR HURRAH, WE HUGGED IN THE WINGS AND FELT SAD FOR MAYBE THE FIRST TIME ALL YEAR.

IT WAS MYRIAM'S SUGGESTION TO CREATE AN ALL-ACCESS DOCUMENT OF THE MARATHON TOUR, AND I'M VERY PLEASED THAT I AGREED. IT IS SO GREAT TO HAVE THIS AS A MEMORY OF A VERY SPECIAL YEAR. THANKS FROM ALL OF US, AND THAT WOULD BE MIKE GARSON, GERRY LEONARD, STERLING CAMPBELL, CATHERINE RUSSELL, GAIL ANN DORSEY, EARL SLICK, MARK PLATI, AND MYSELF. I, TOO, MUST THANK MY ENTIRE CREW FOR THE HUGE AMOUNT OF WORK AND ENTHUSIASM THEY THROW INTO ALL OUR ENDEAVORS.

BY THE TIME I WRITE THIS I GUESS I WILL BE PLANNING THE NEXT TOUR FOR 2003/4. ALL I CAN HOPE IS THAT WE HAVE THE SAME KIND OF EXPERIENCE THAT THRILLED US SO MUCH ON THE 2002 LEG. IT REALLY WAS A SPECIAL YEAR AND WILL BE HARD TO BEAT.

—MAY 2003

David

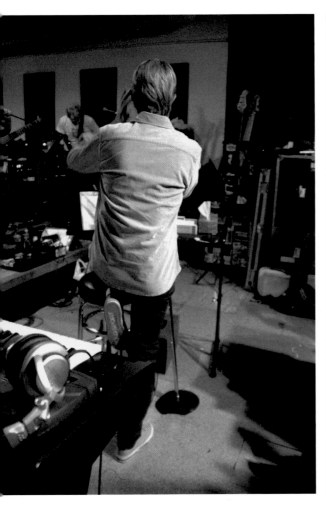
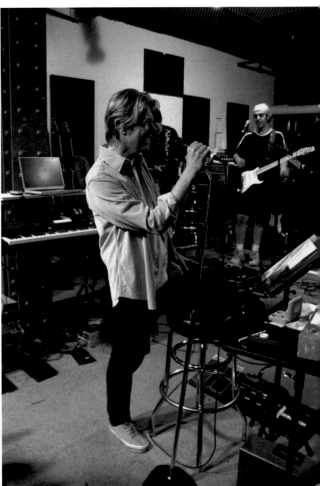

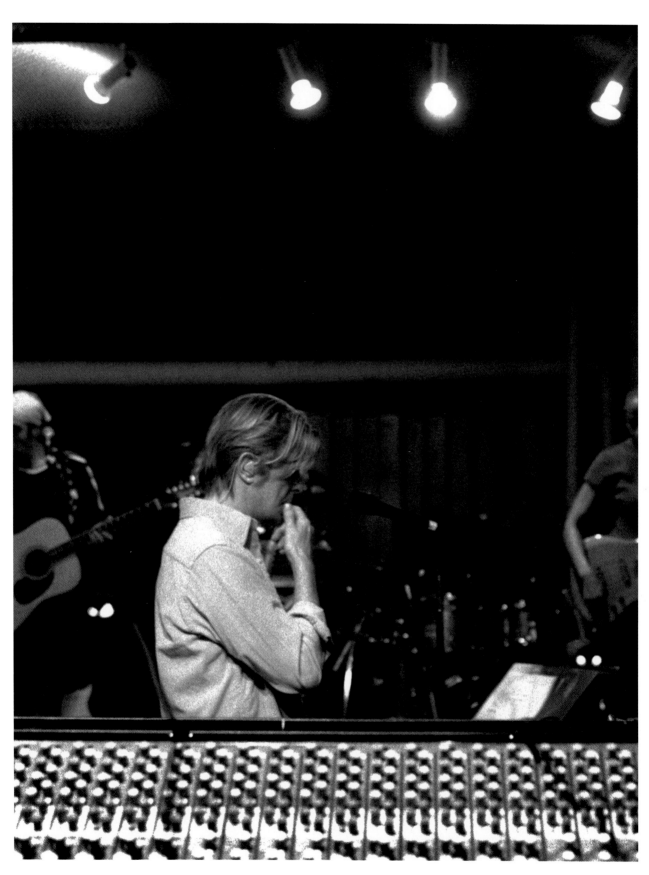

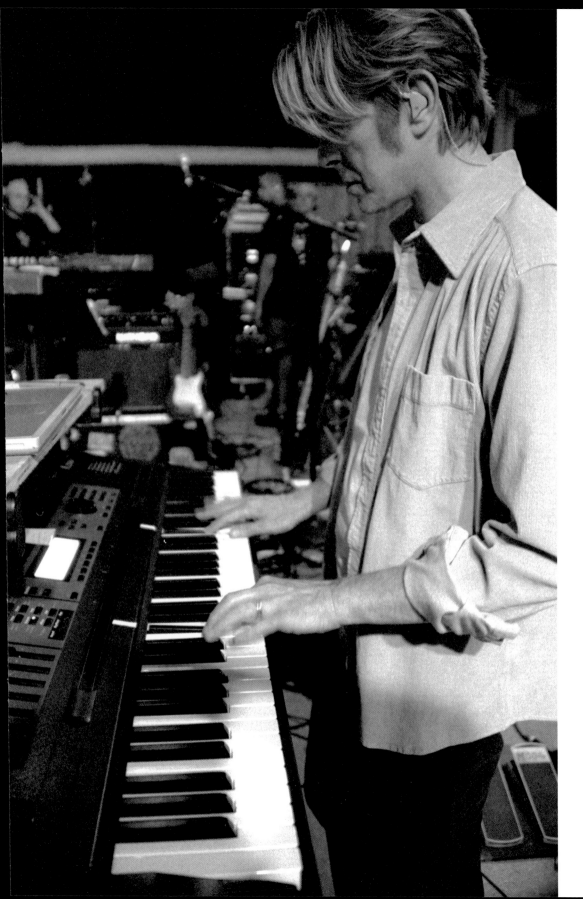

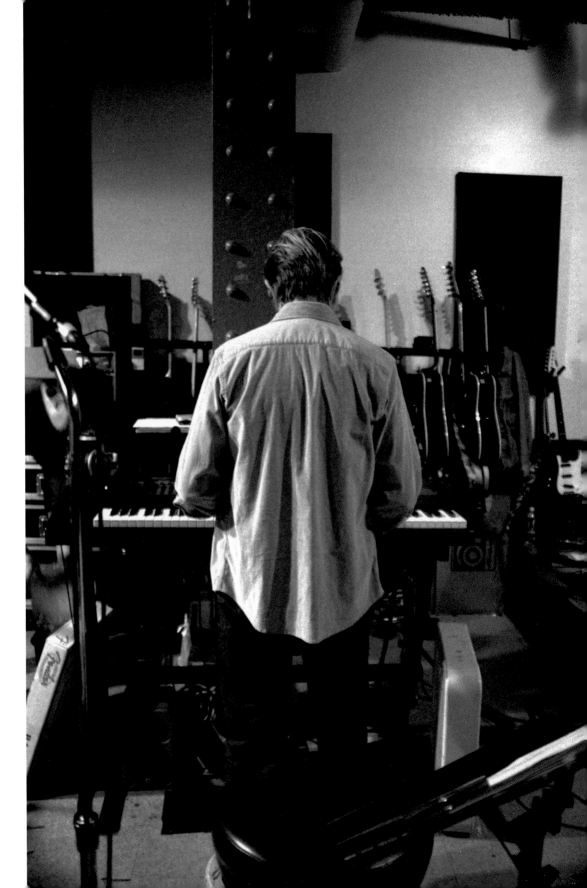

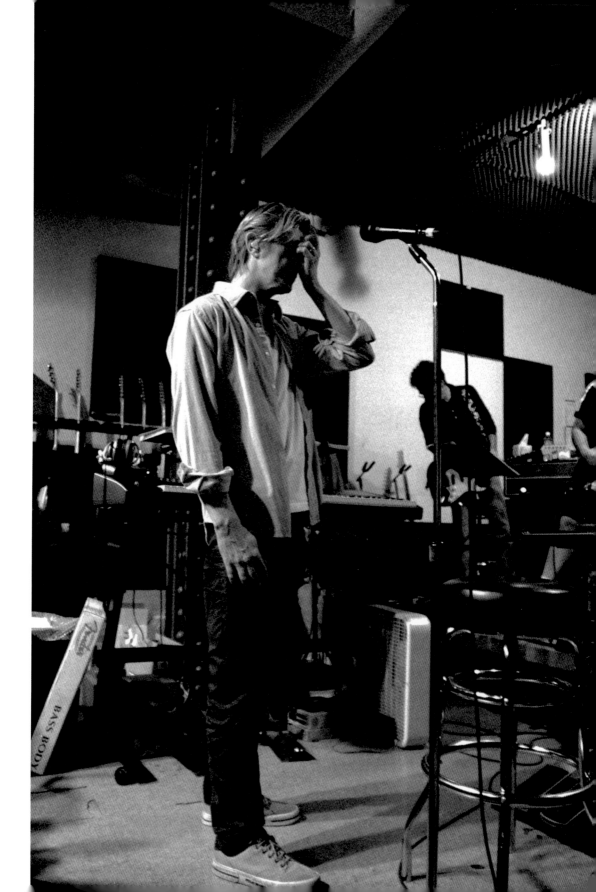

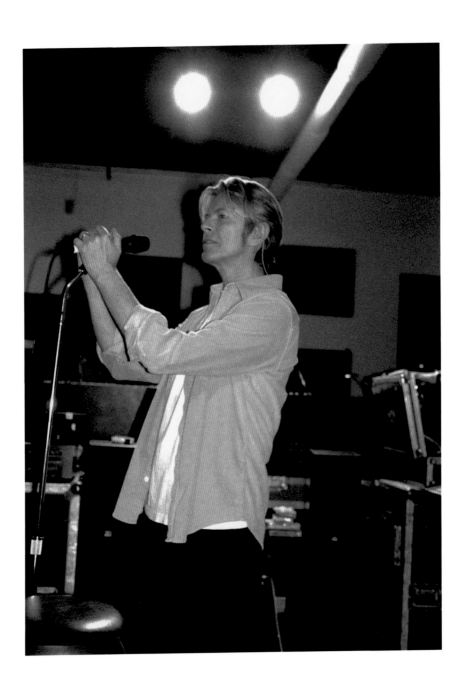

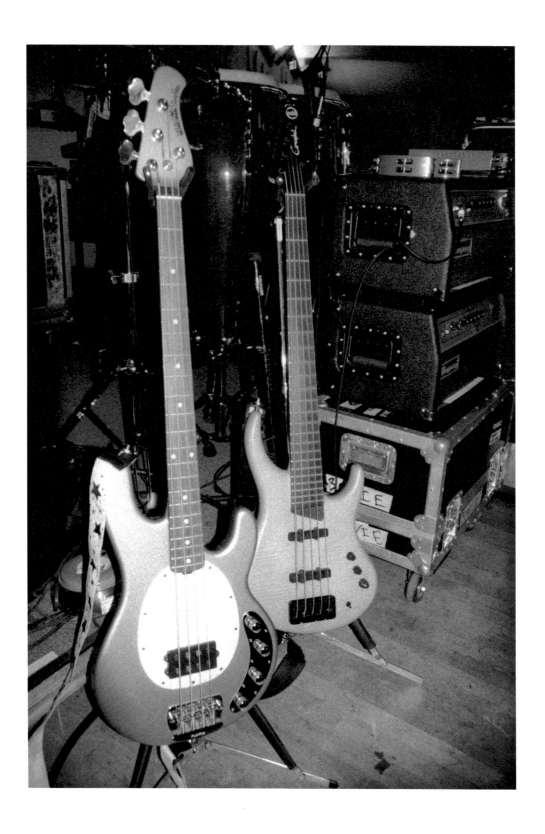

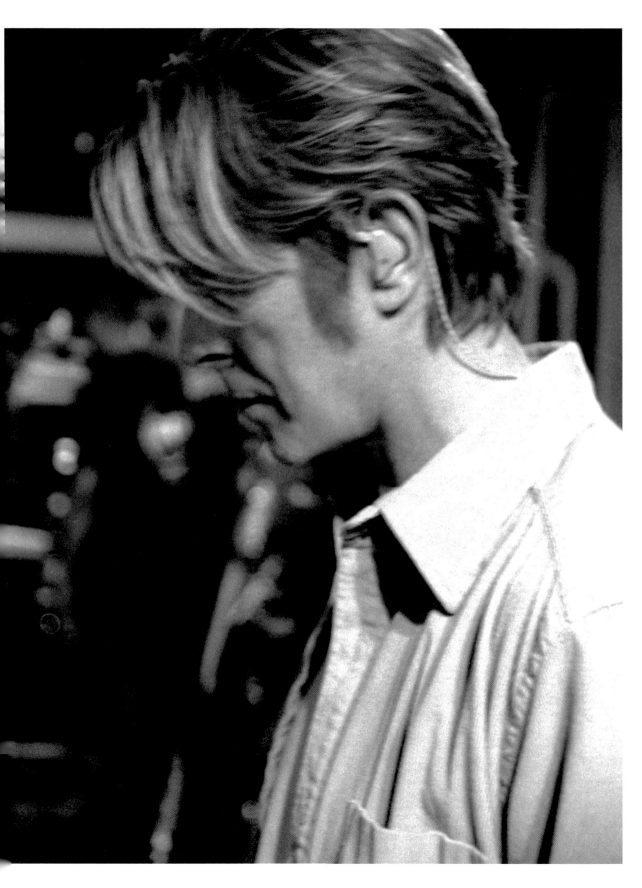

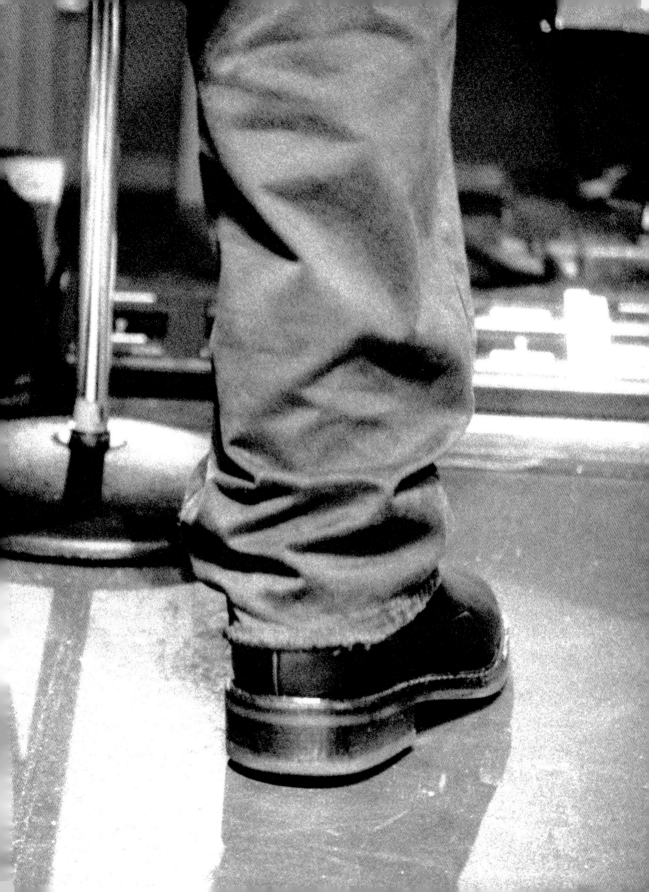

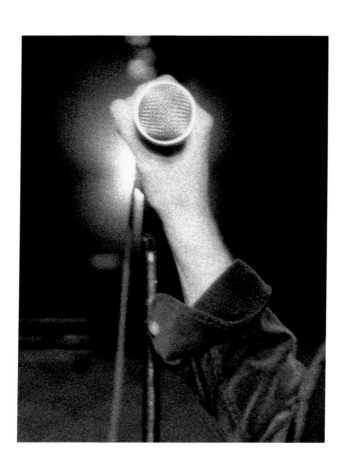

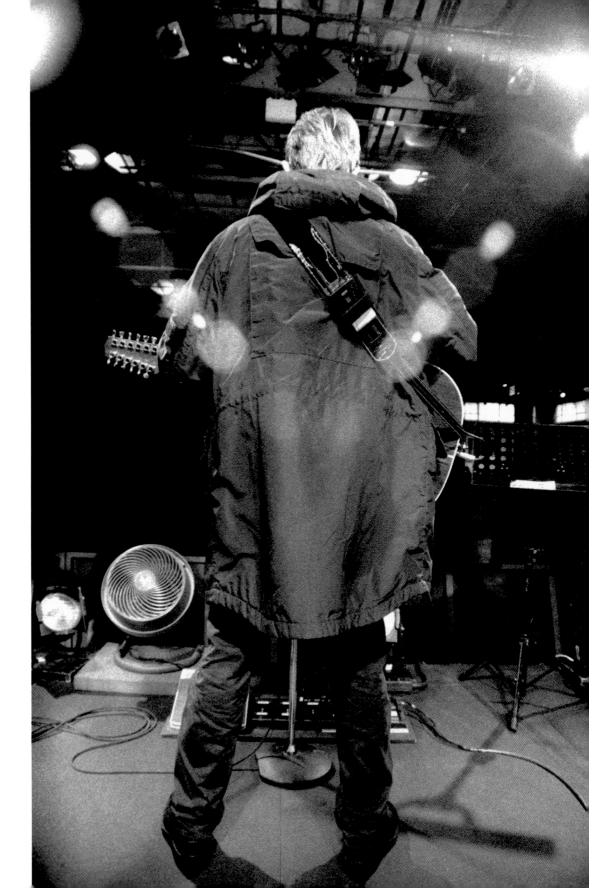

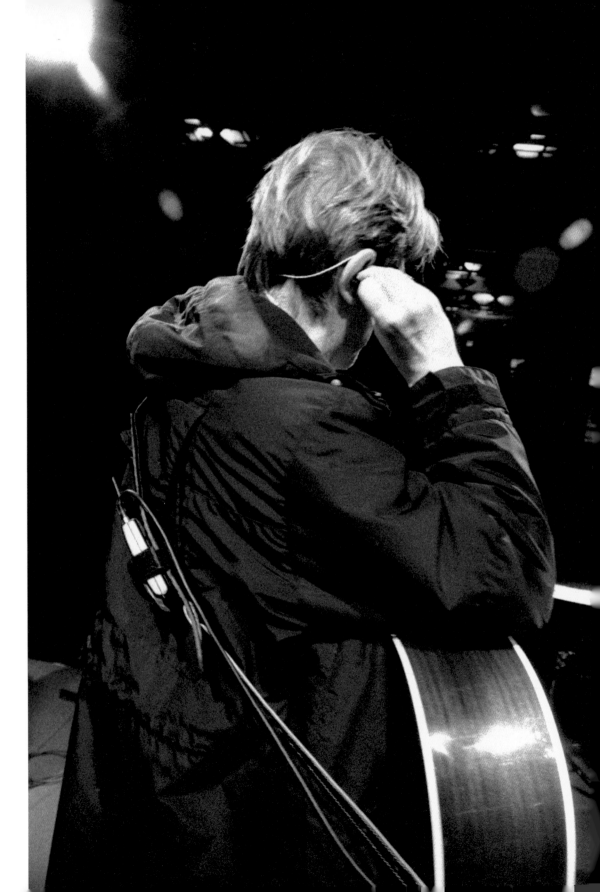

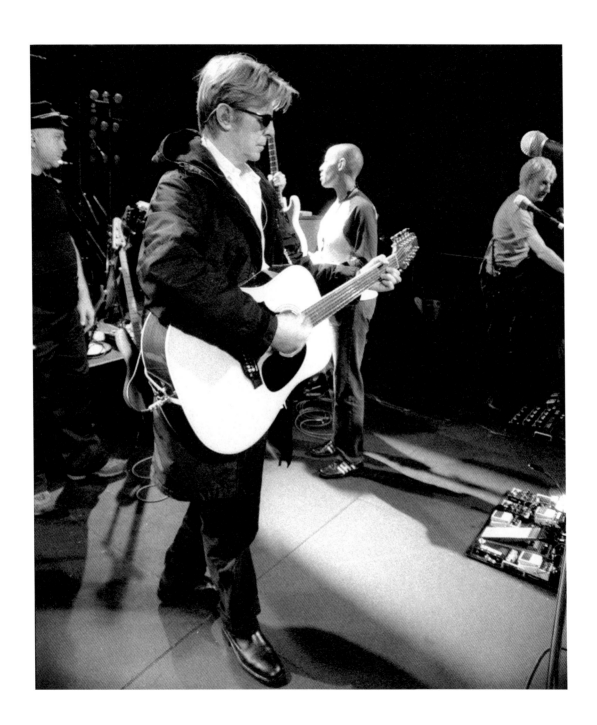

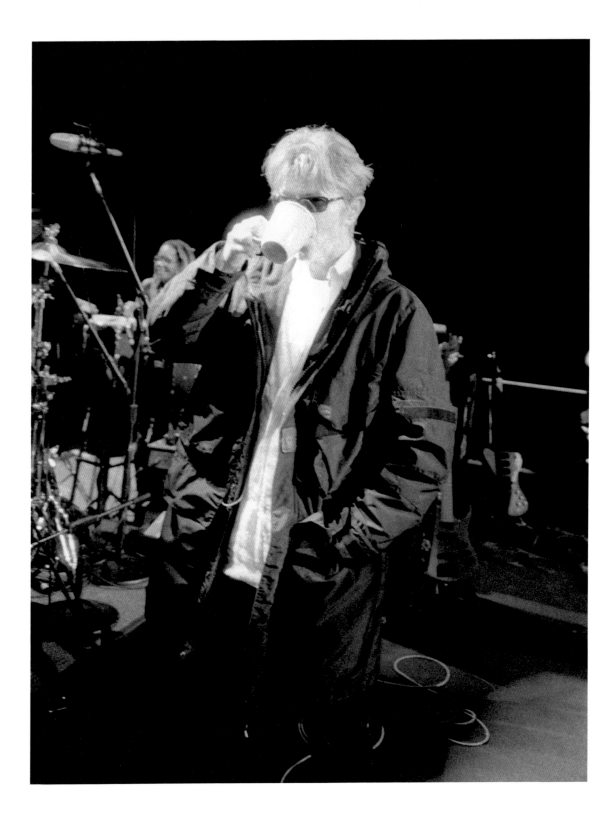

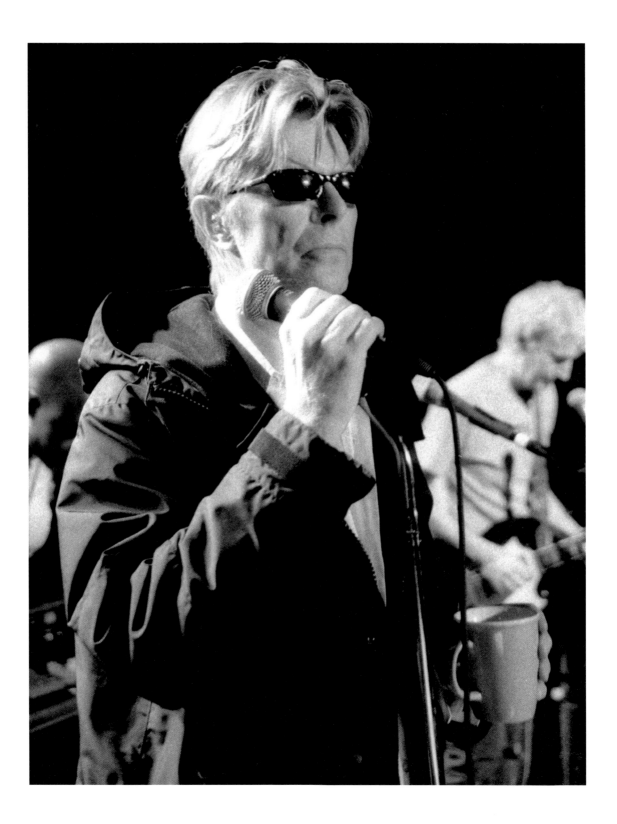

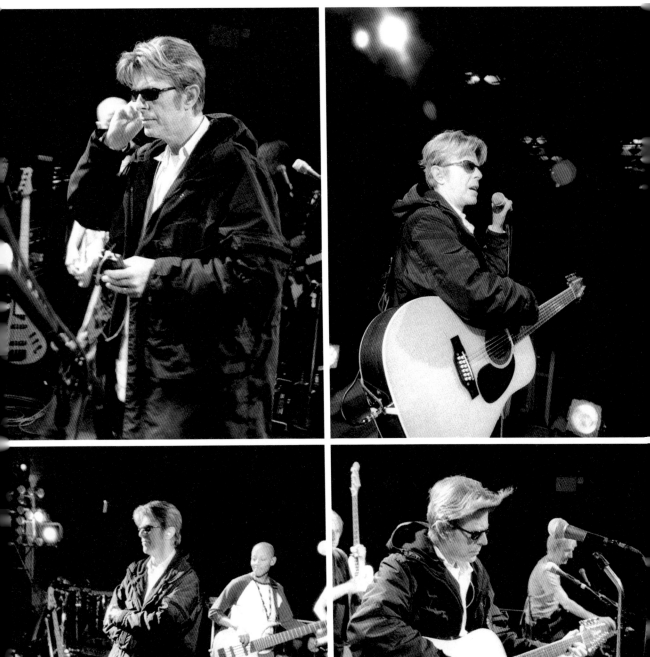
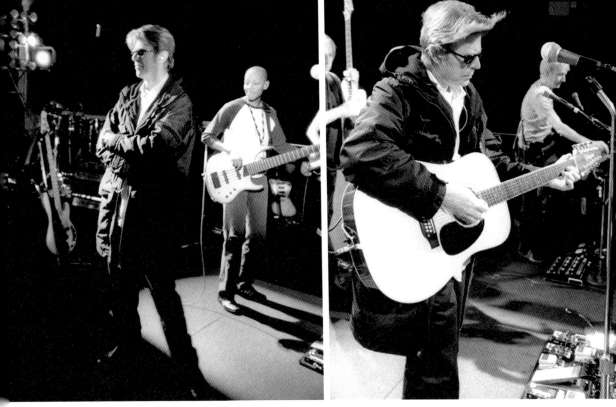

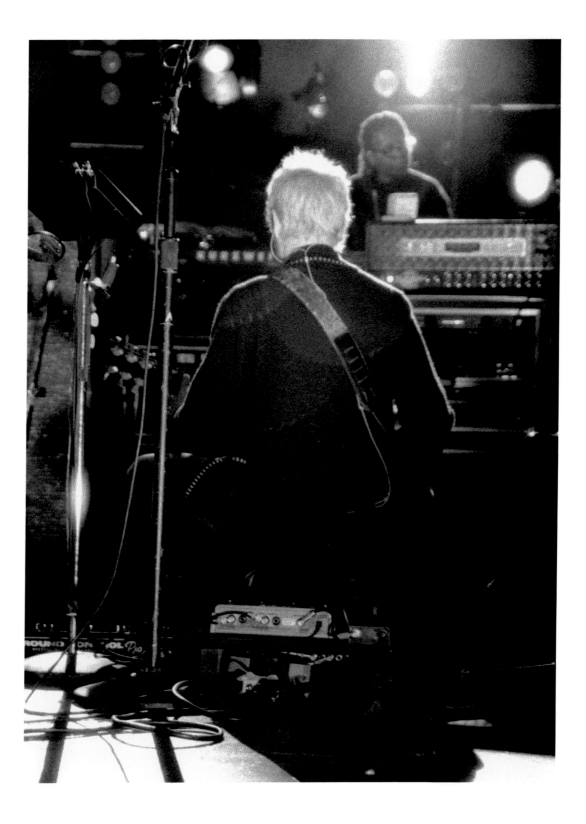

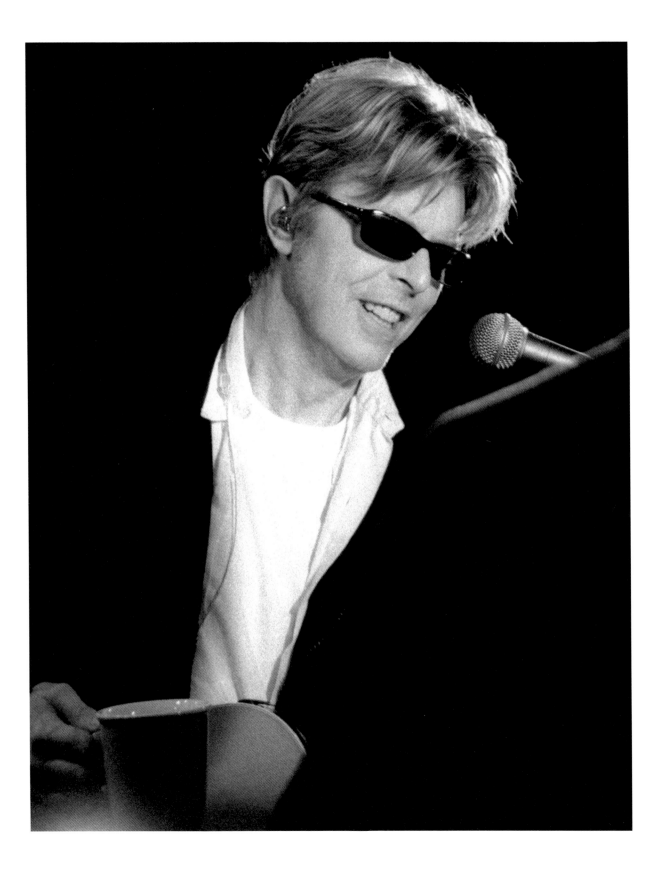

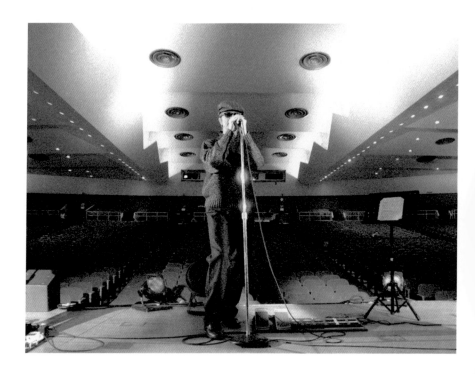

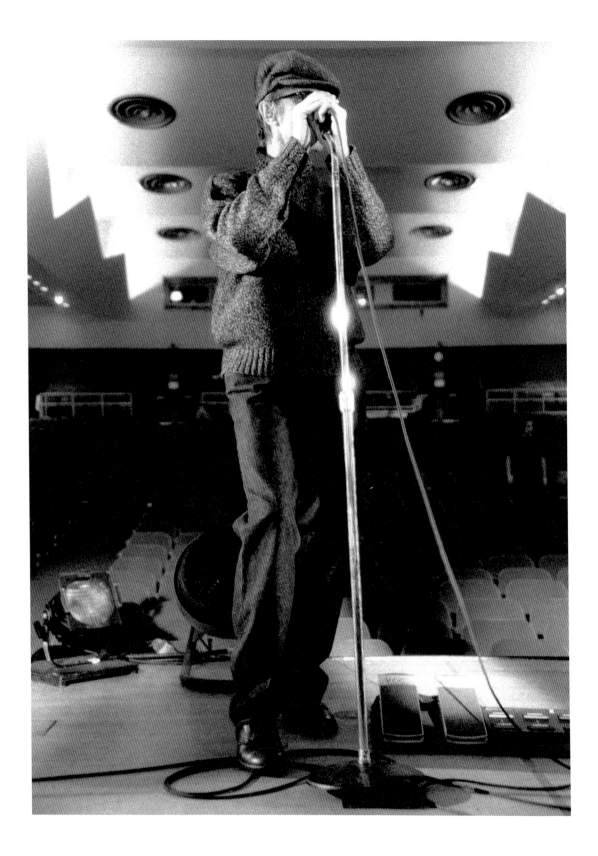

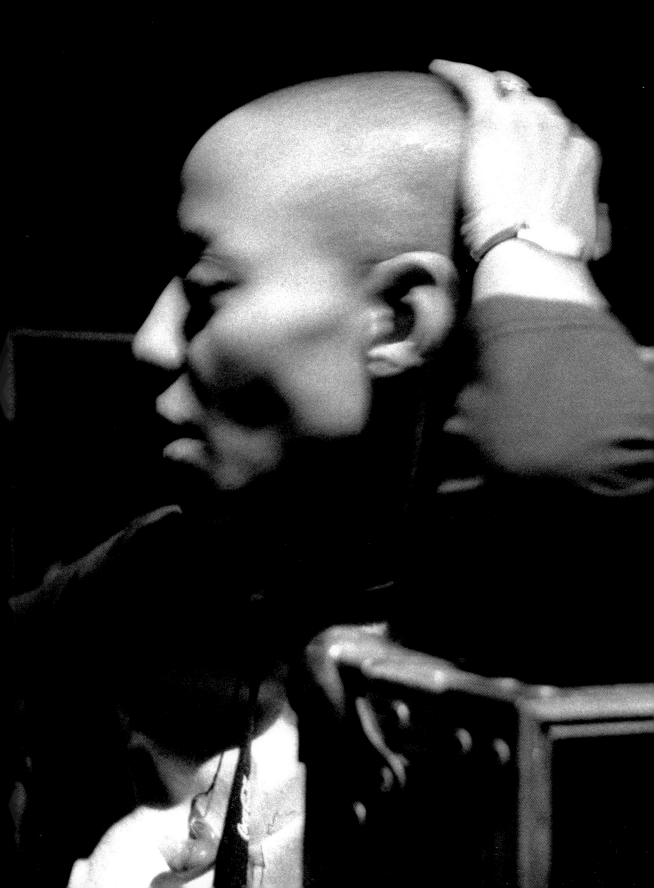

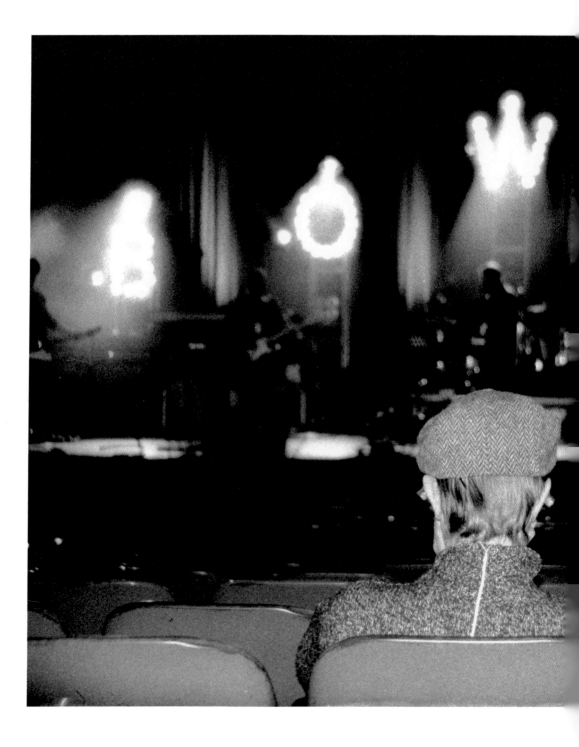

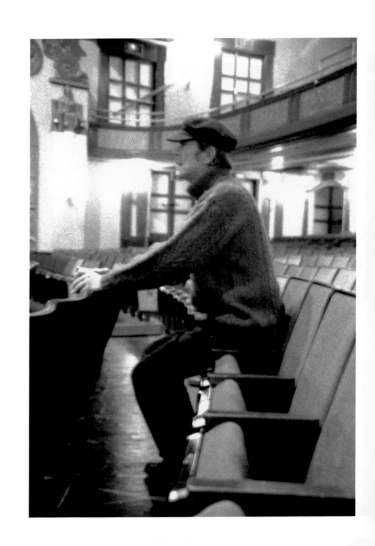

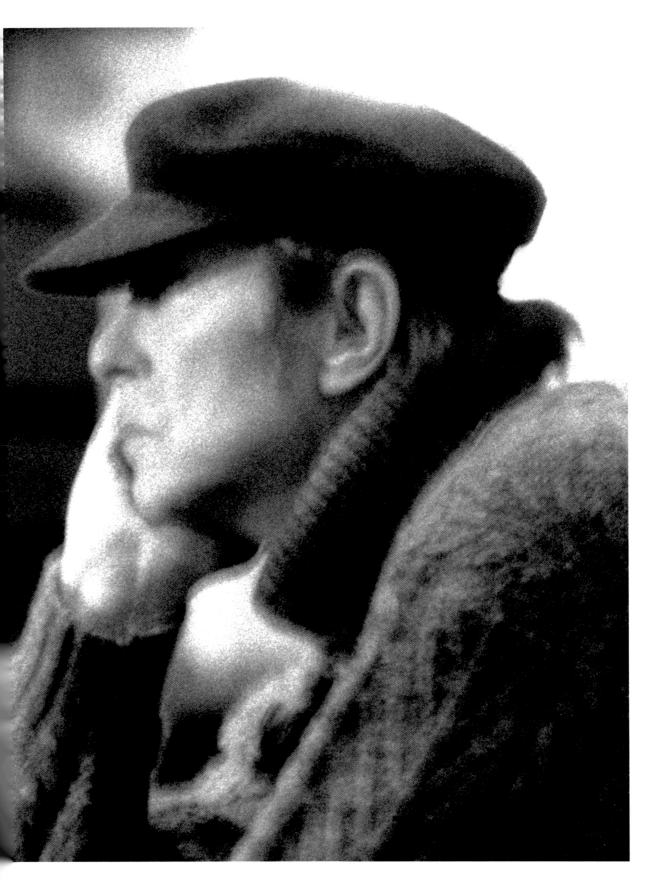

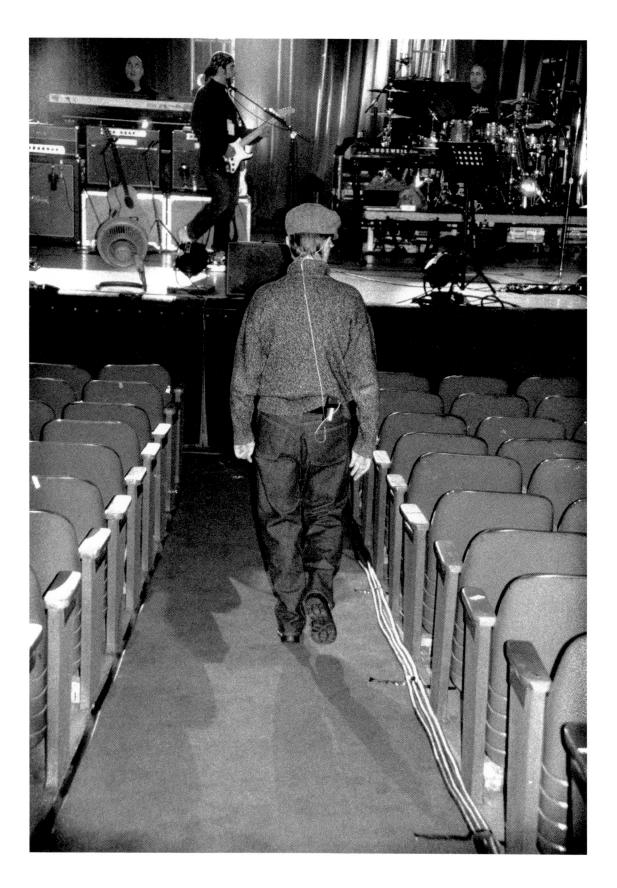

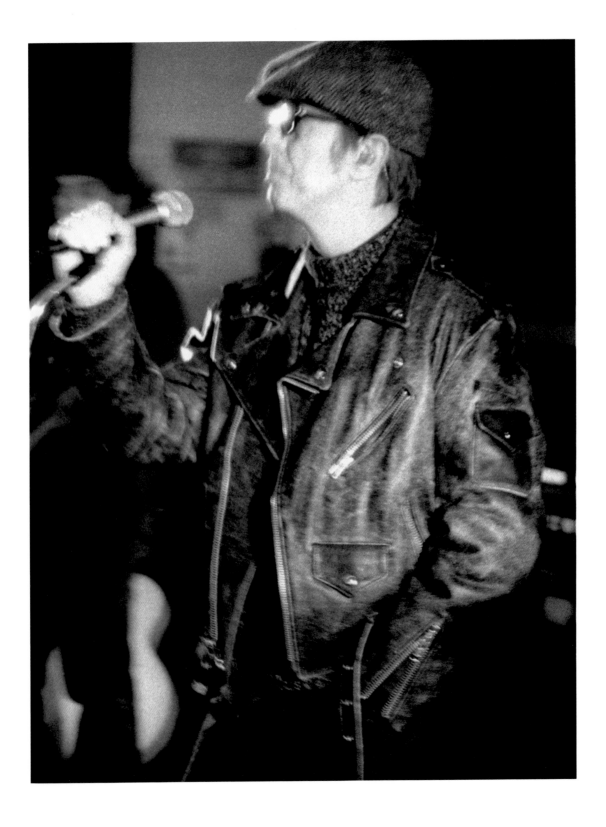

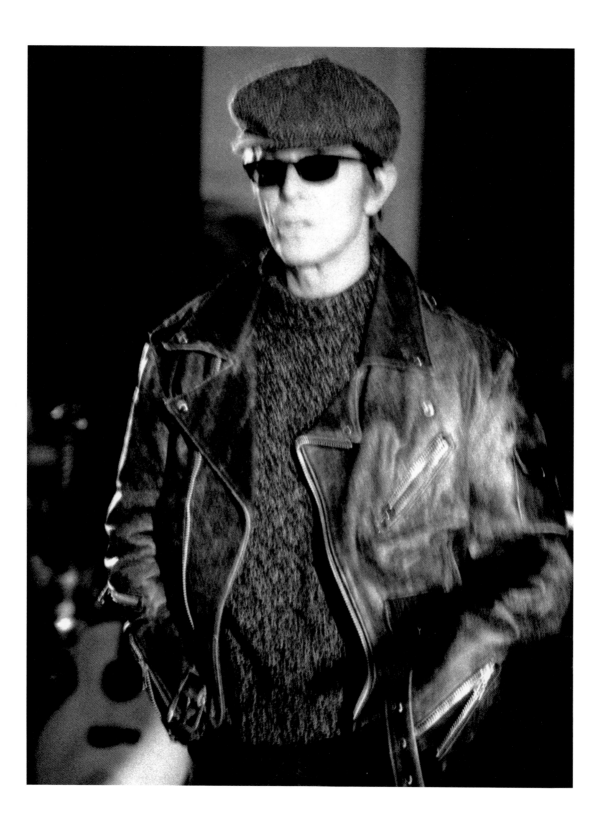

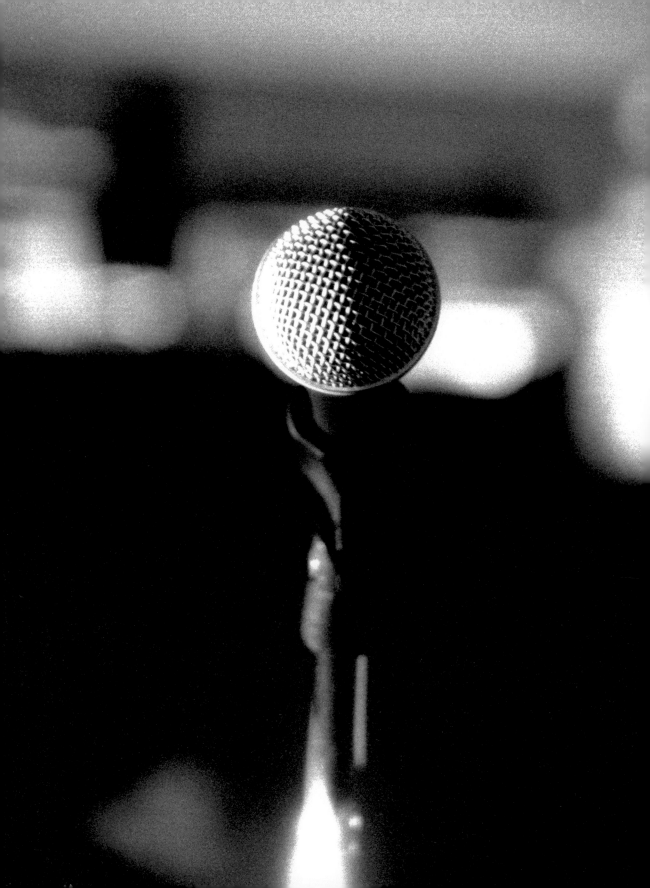

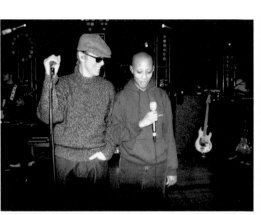
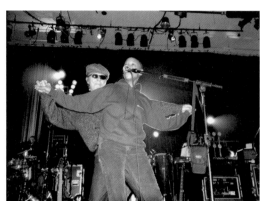
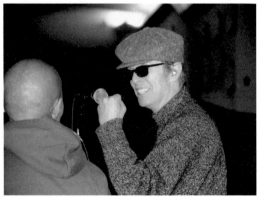
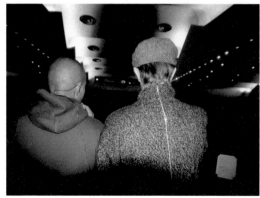

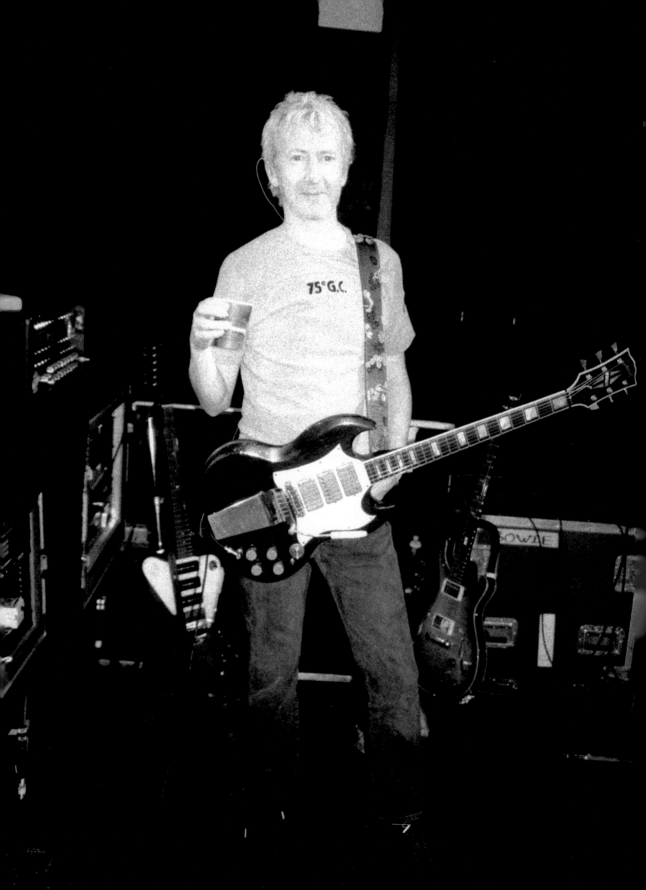

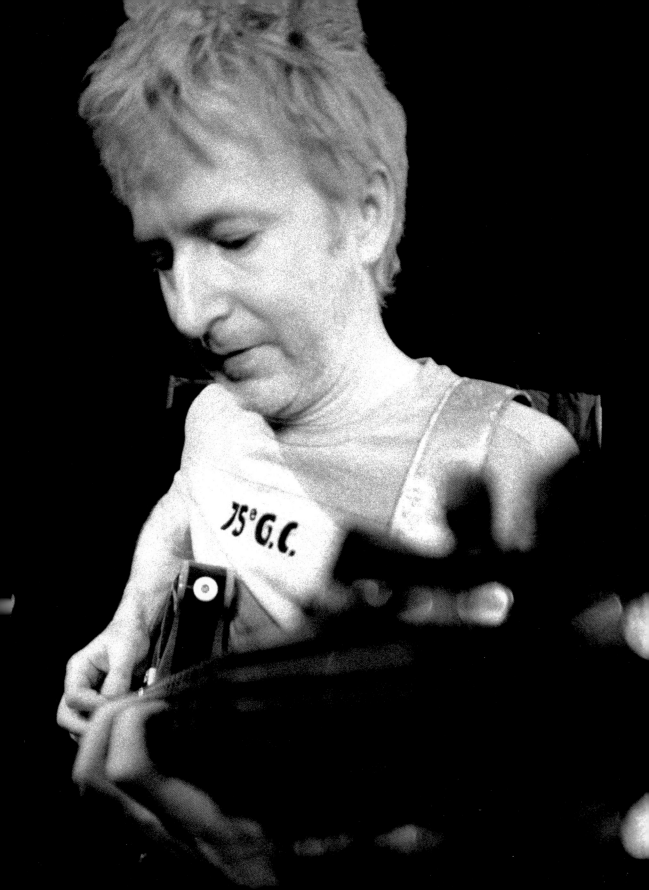

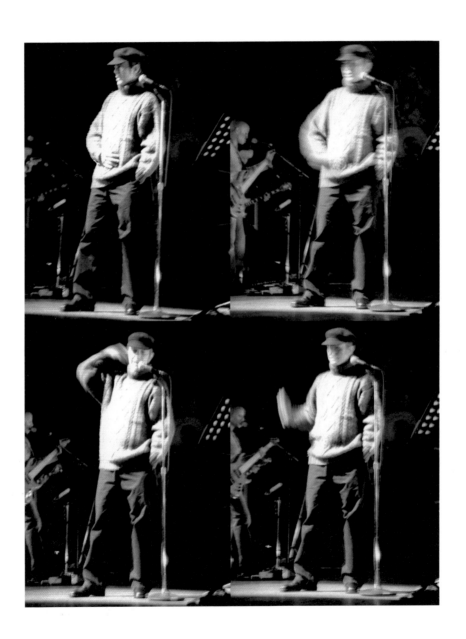

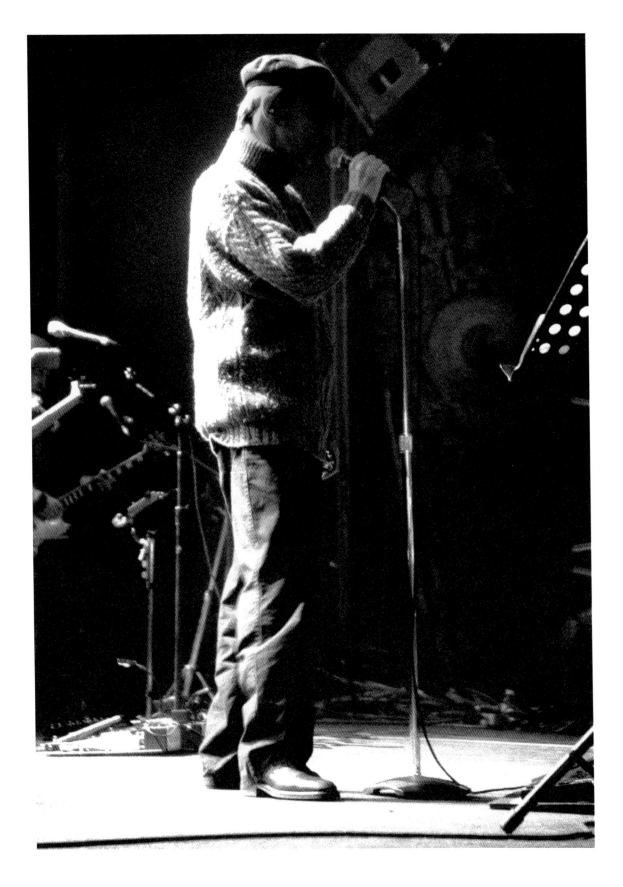

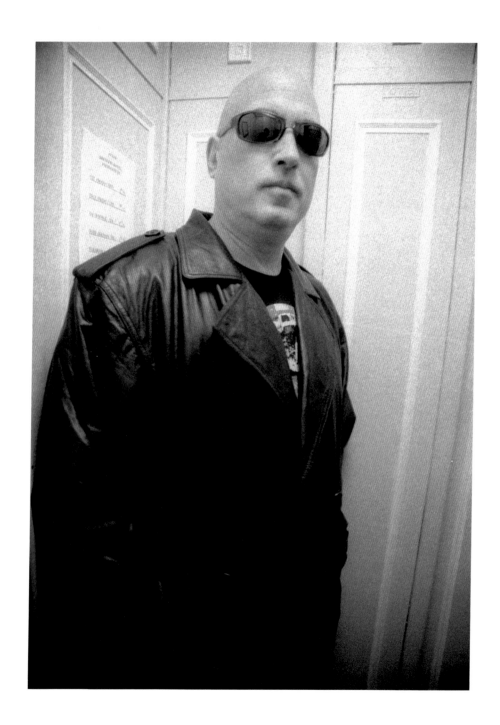

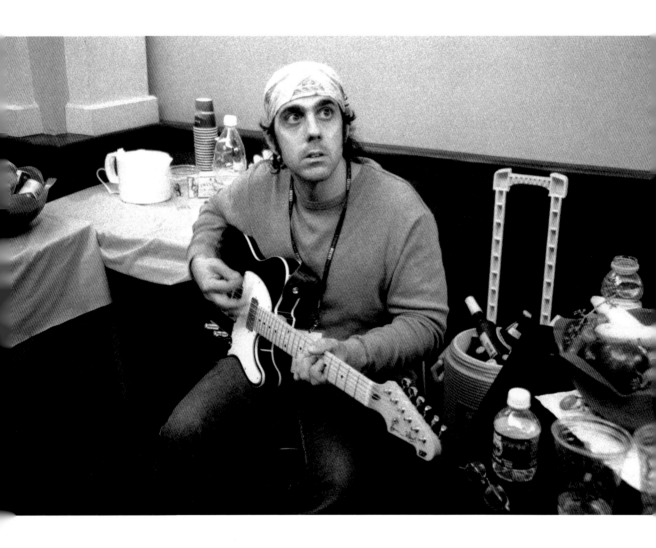

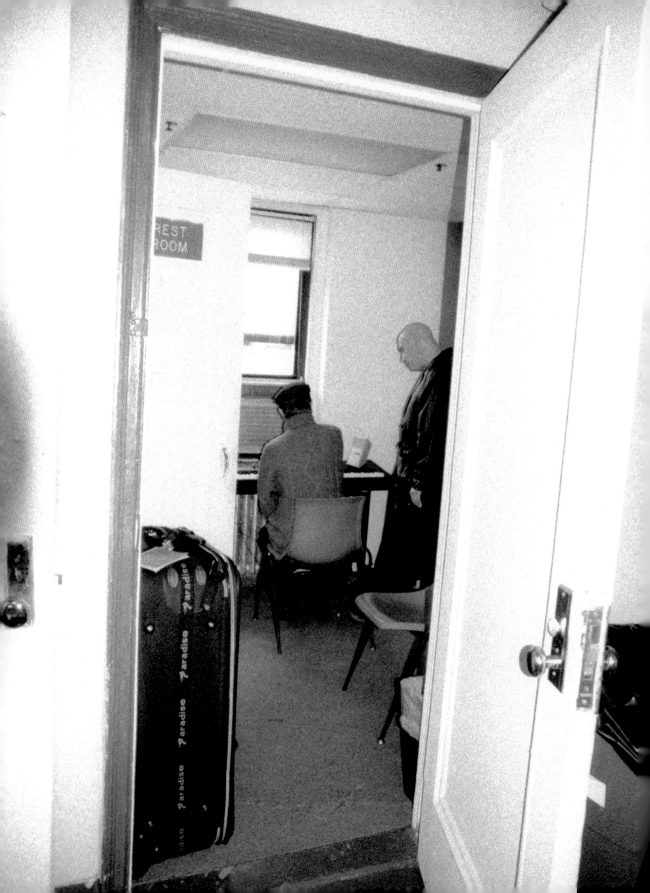

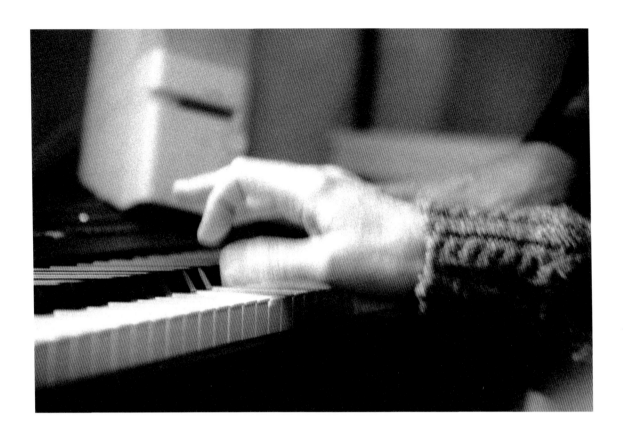

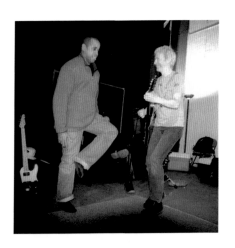
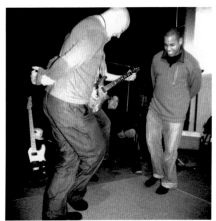
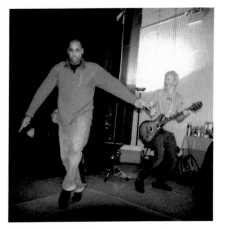
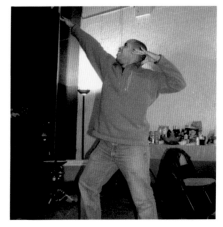

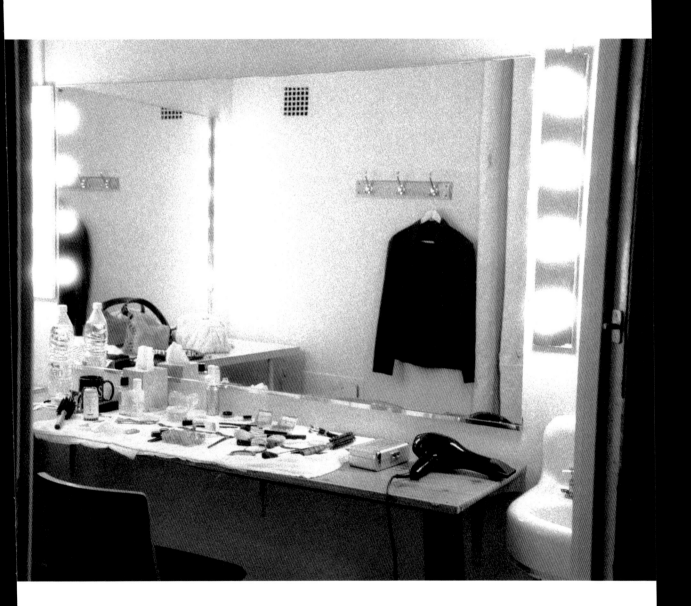

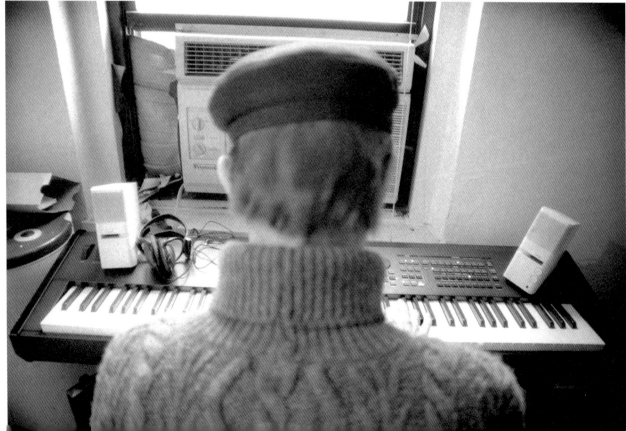

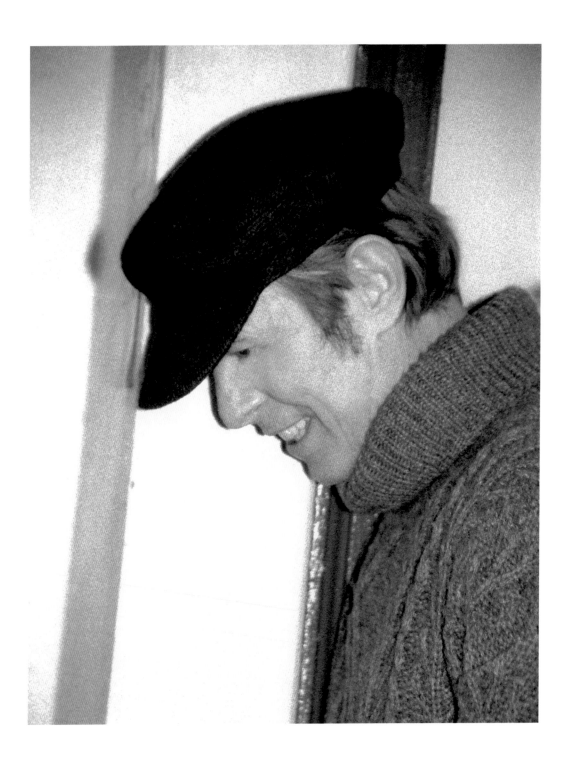

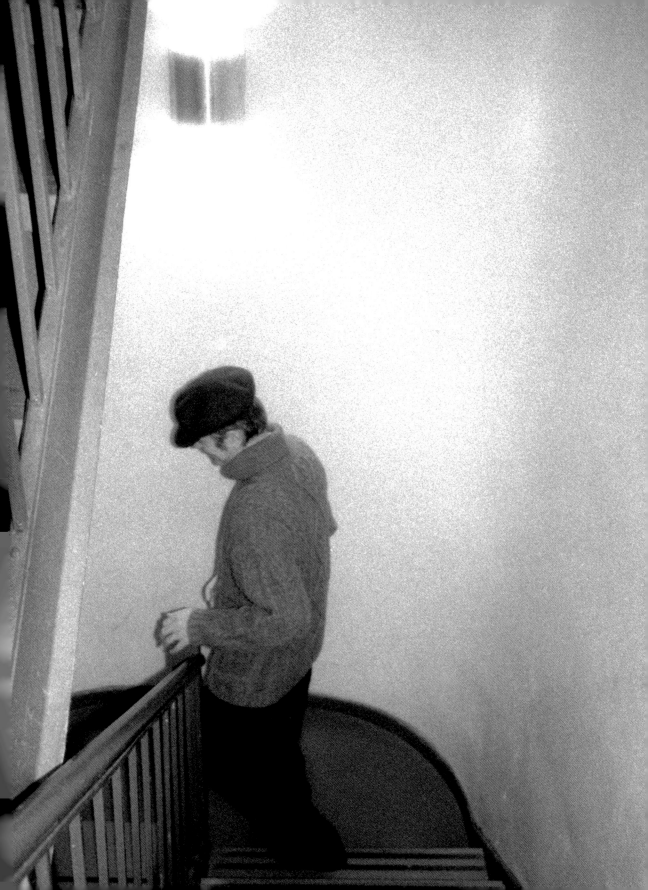

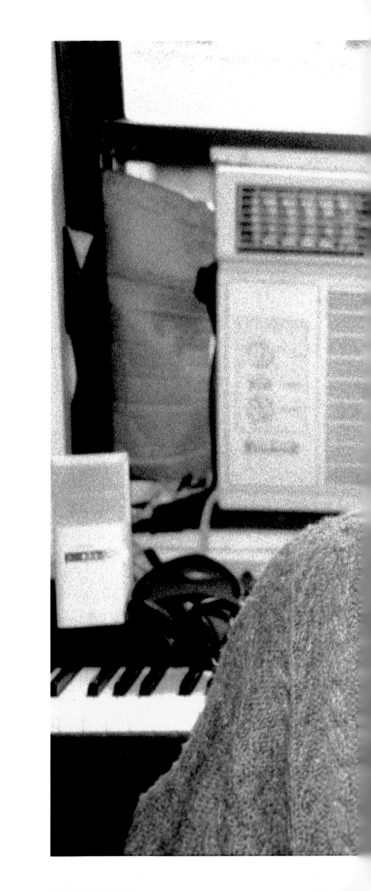

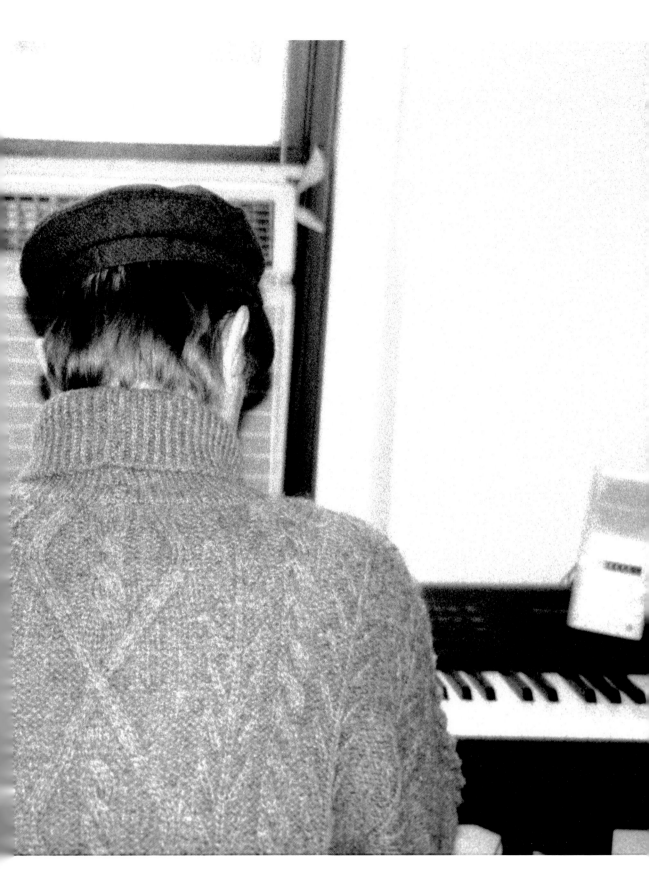

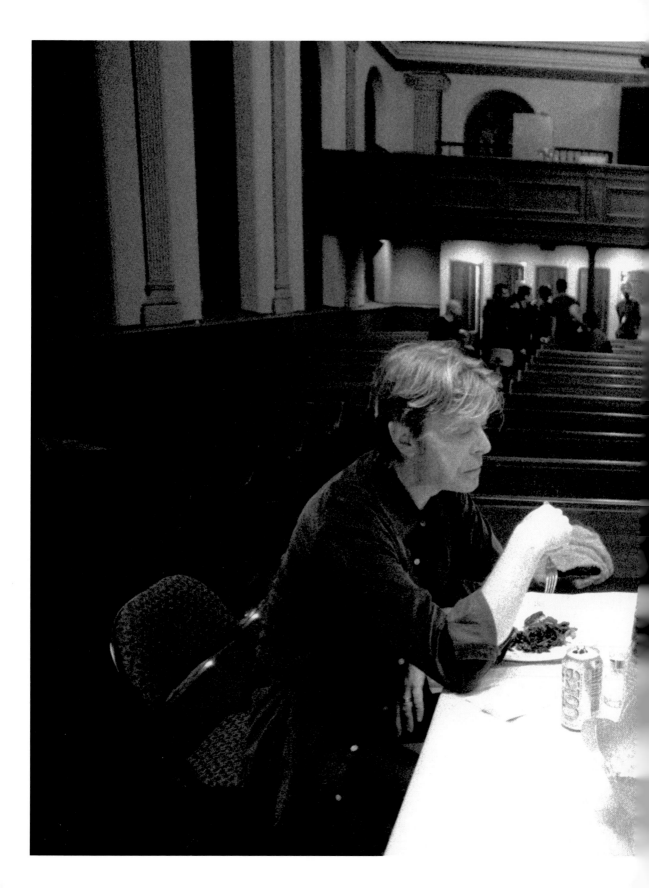

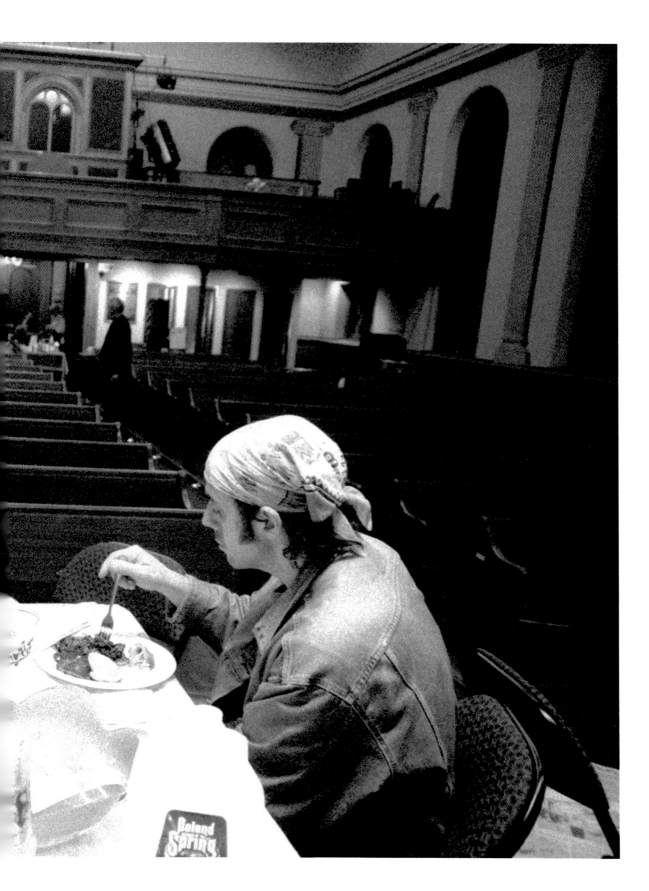

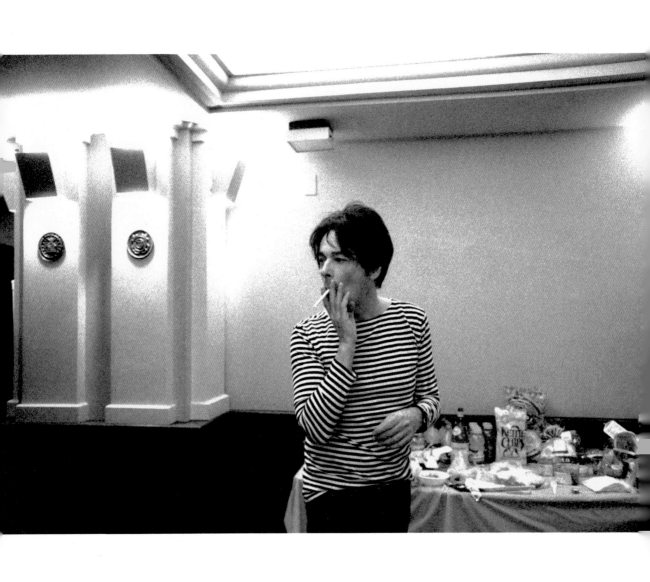

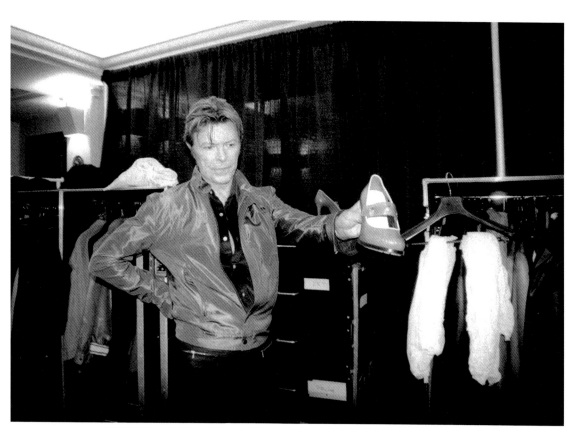

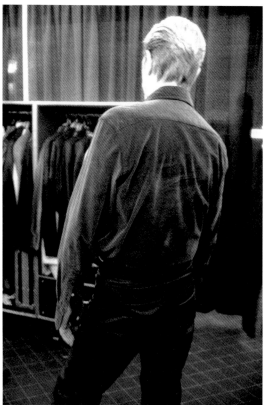

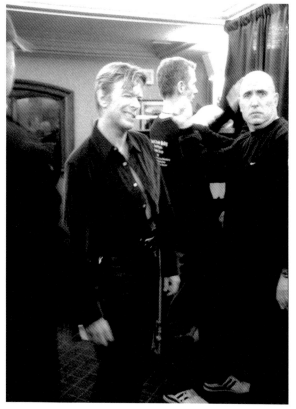

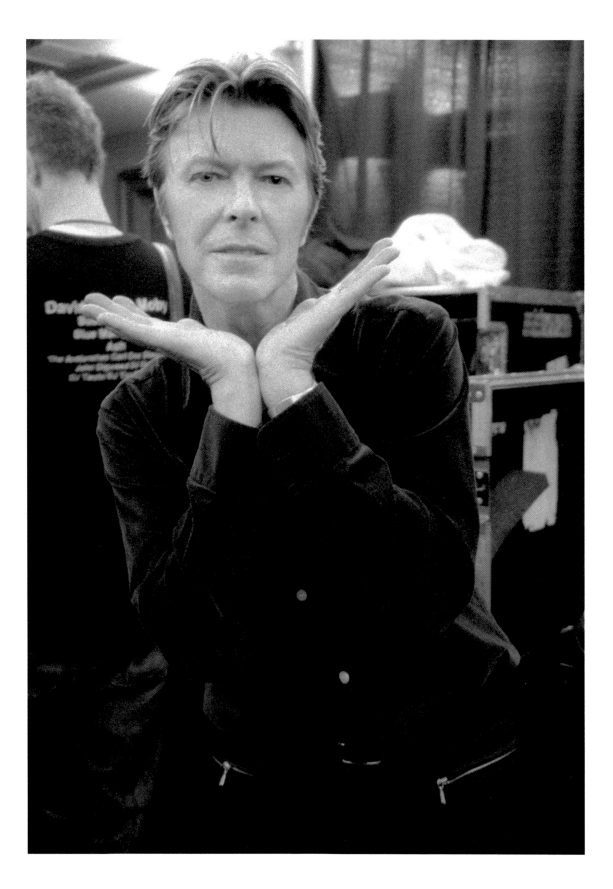

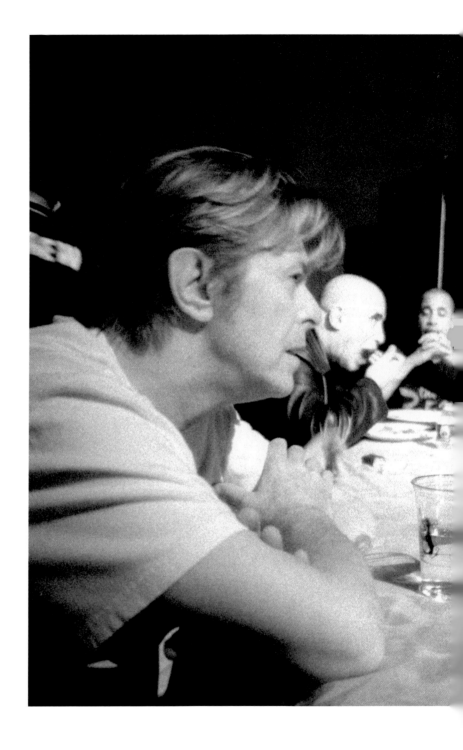

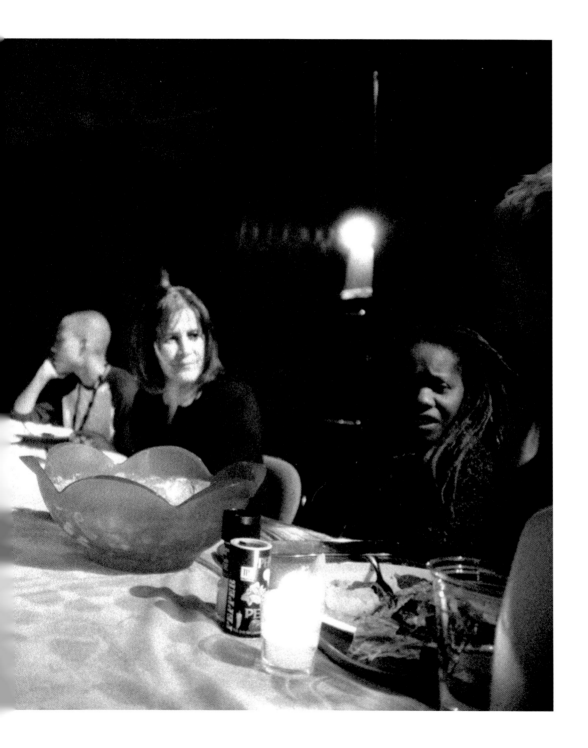

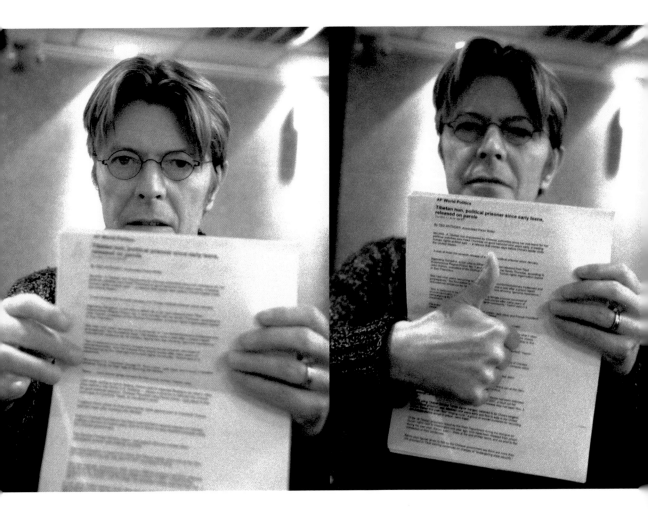

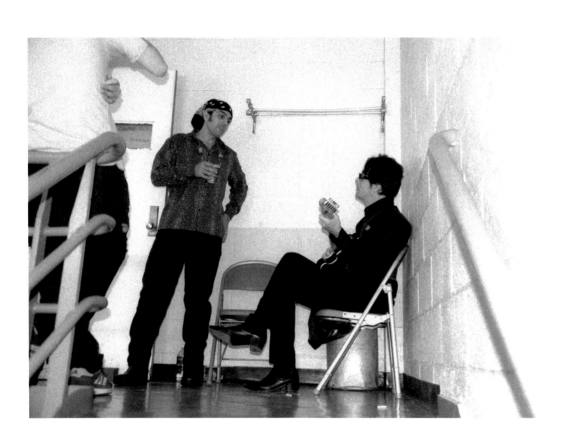

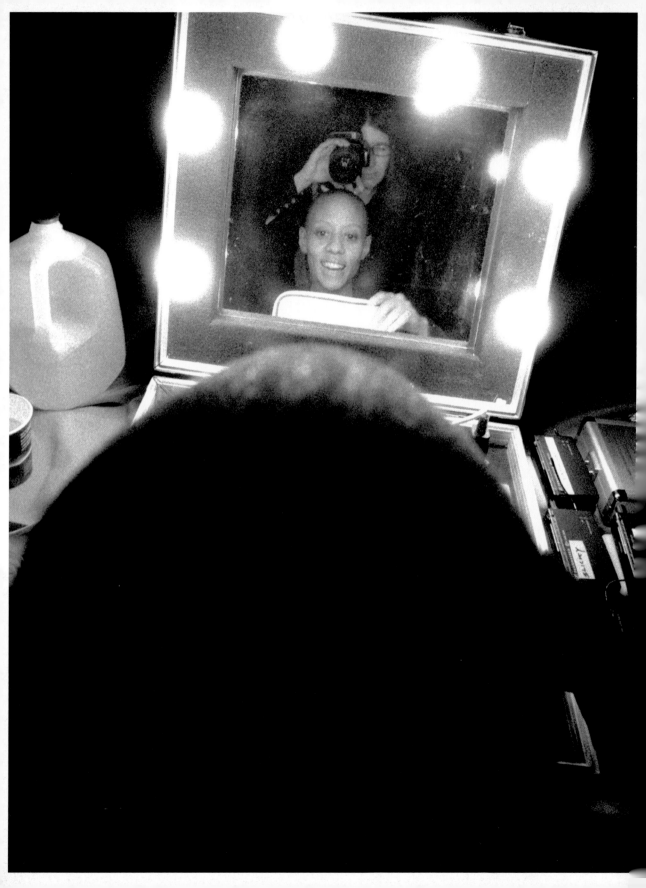

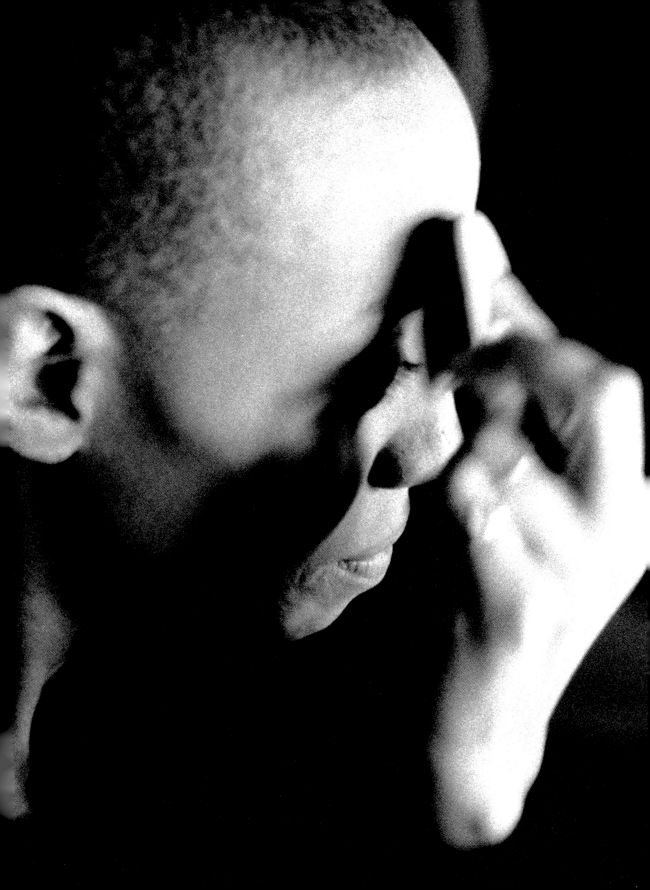

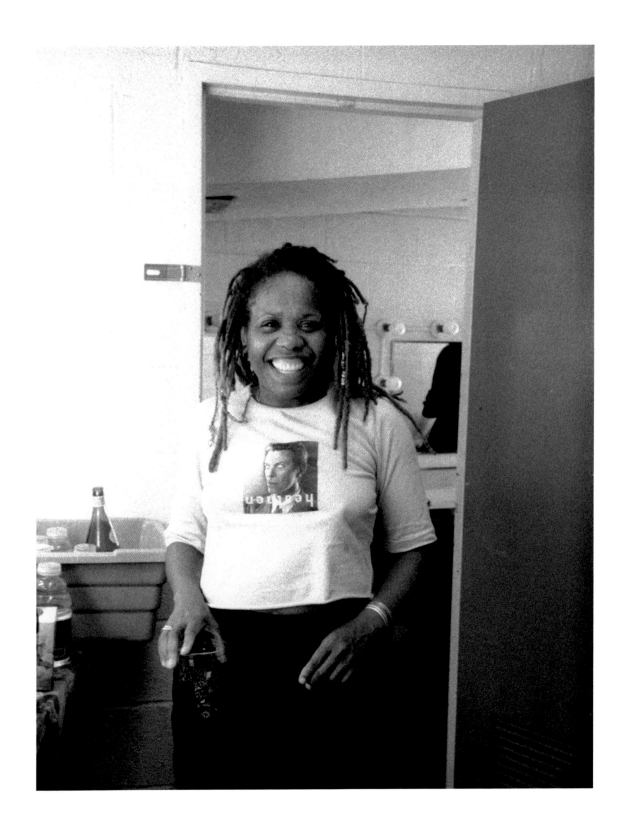

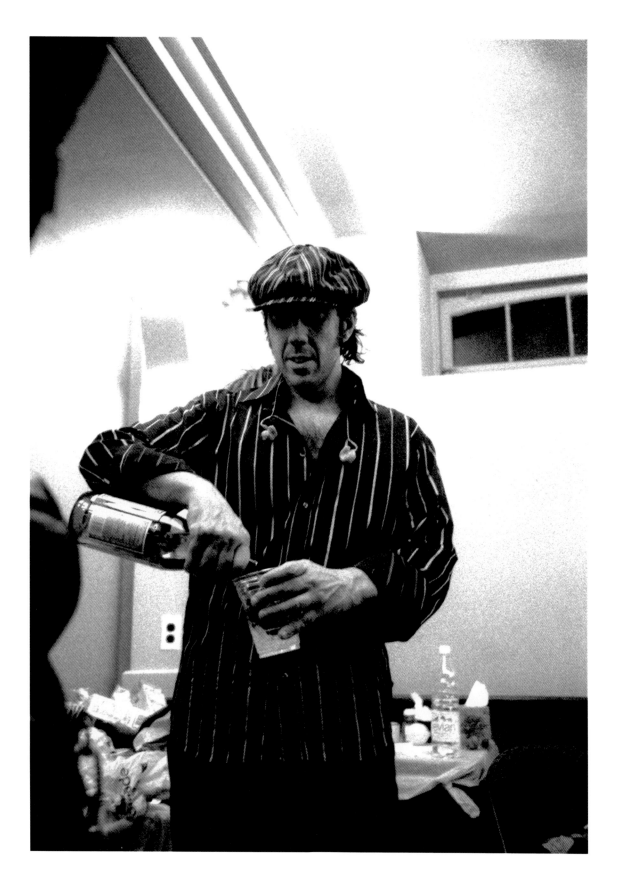

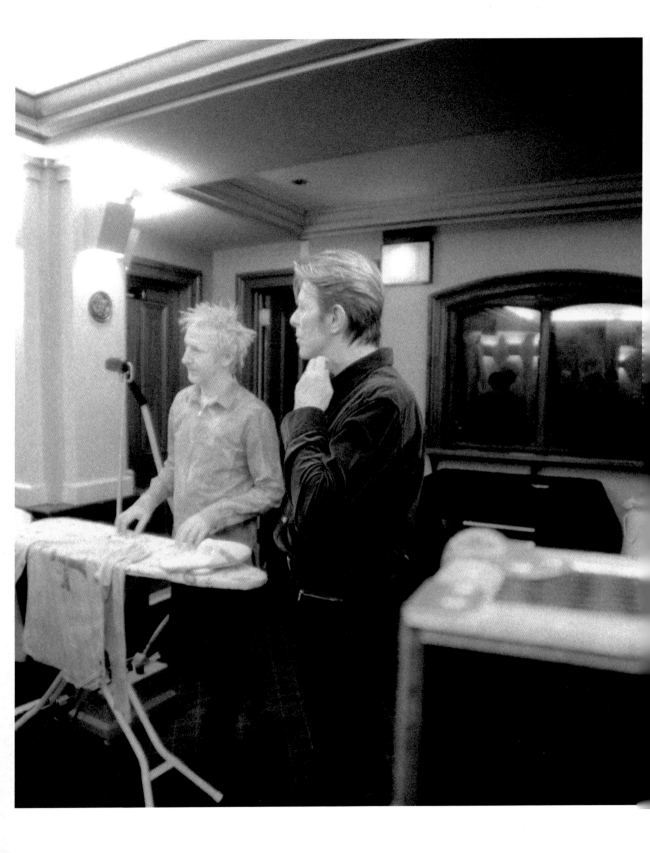

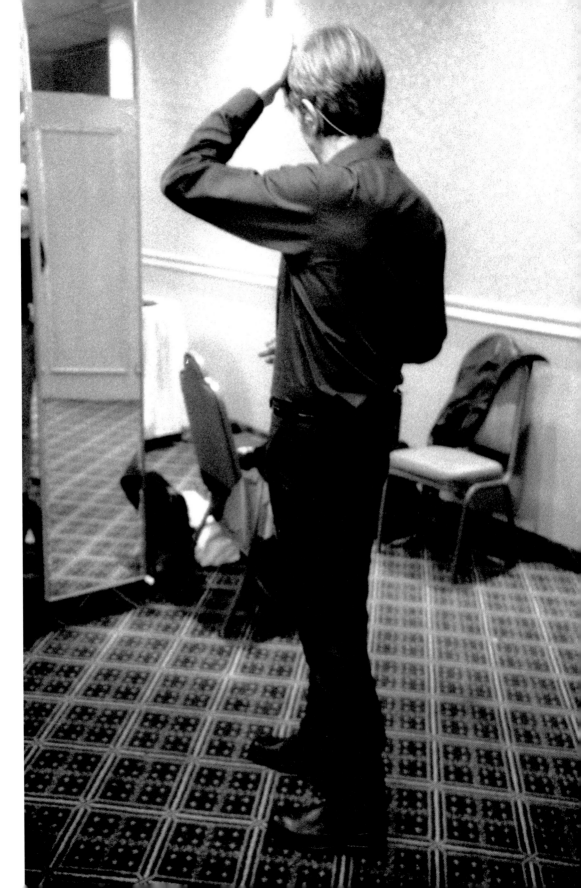

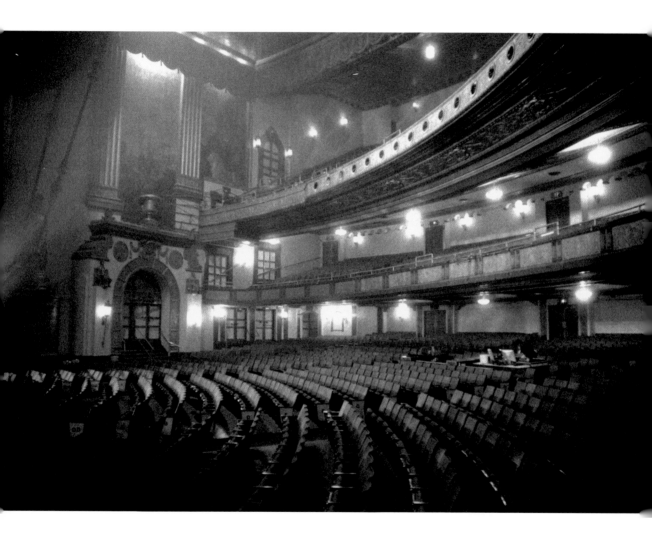

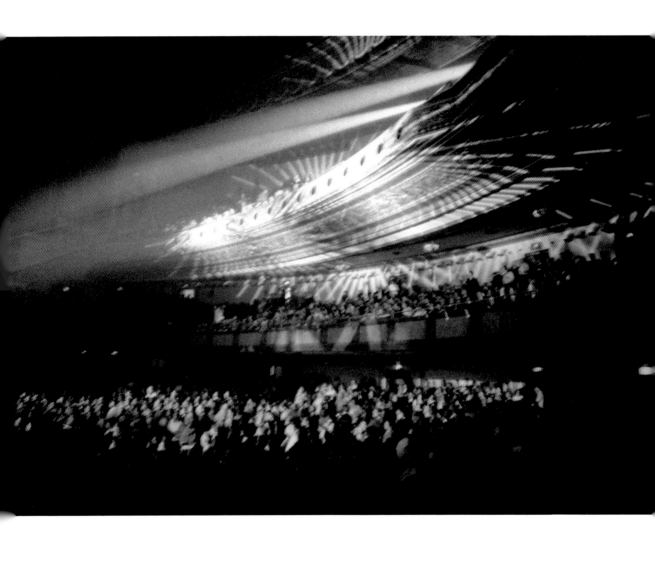

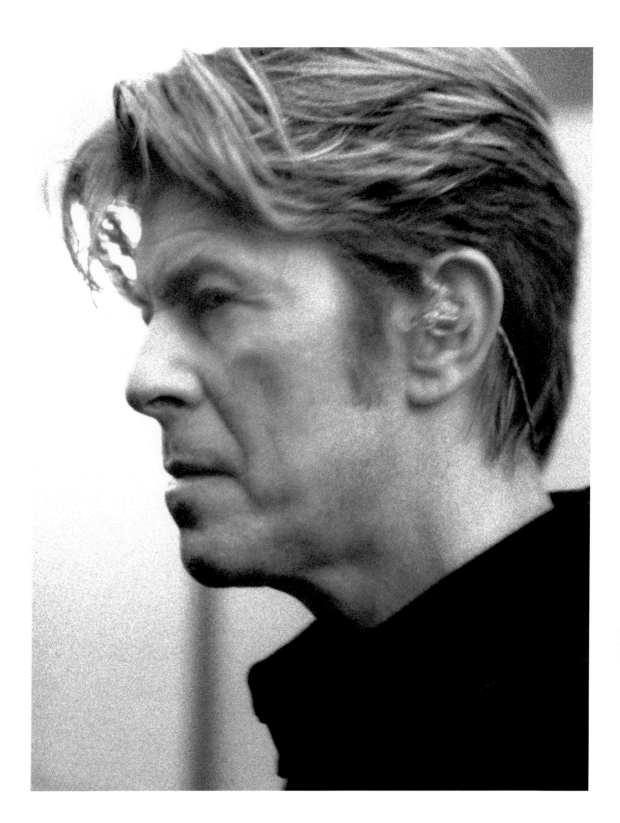

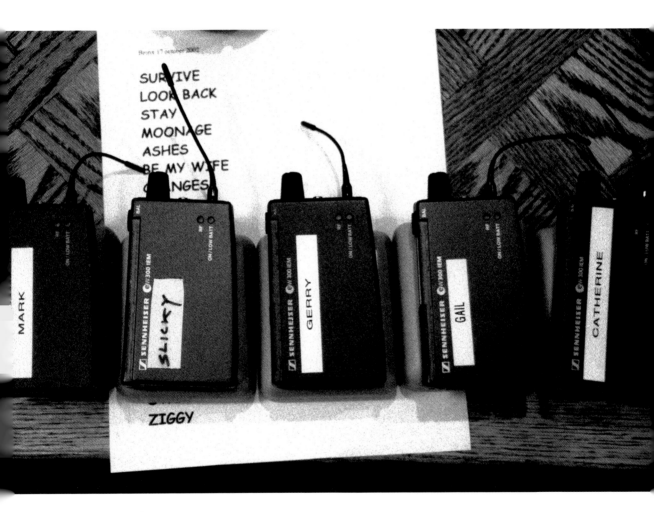

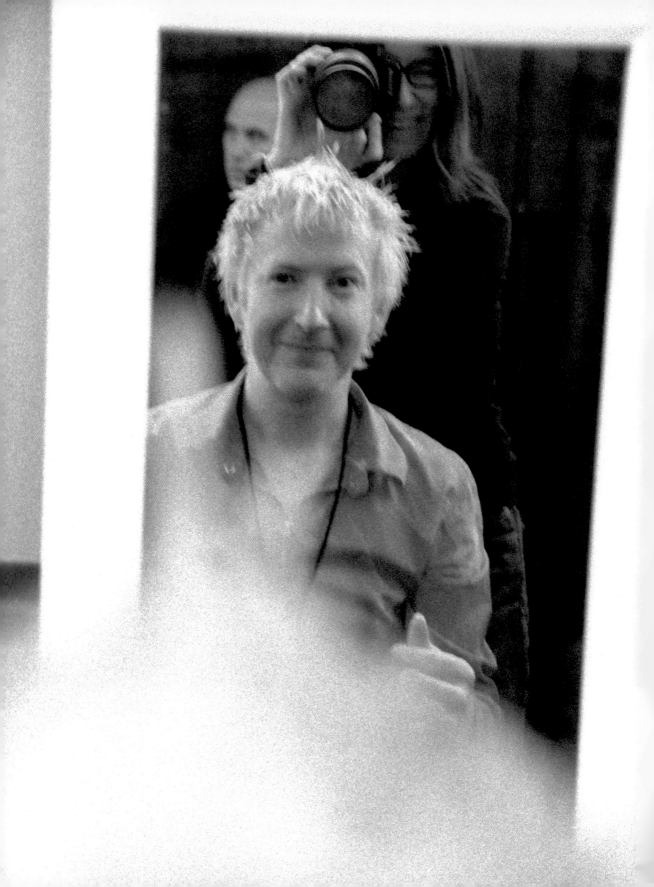

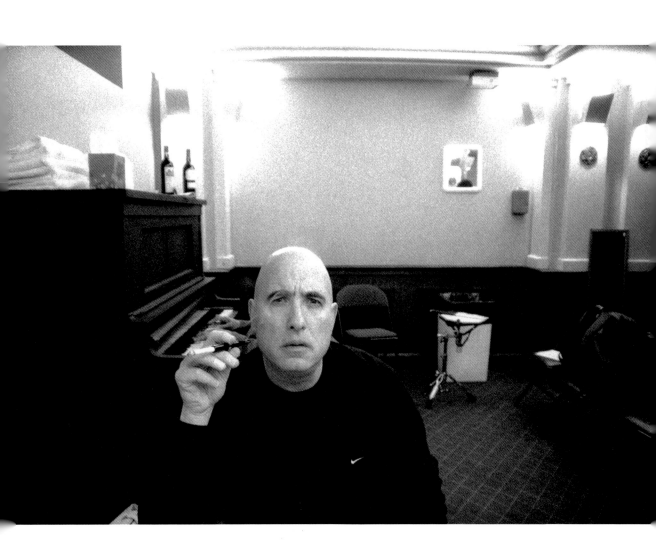

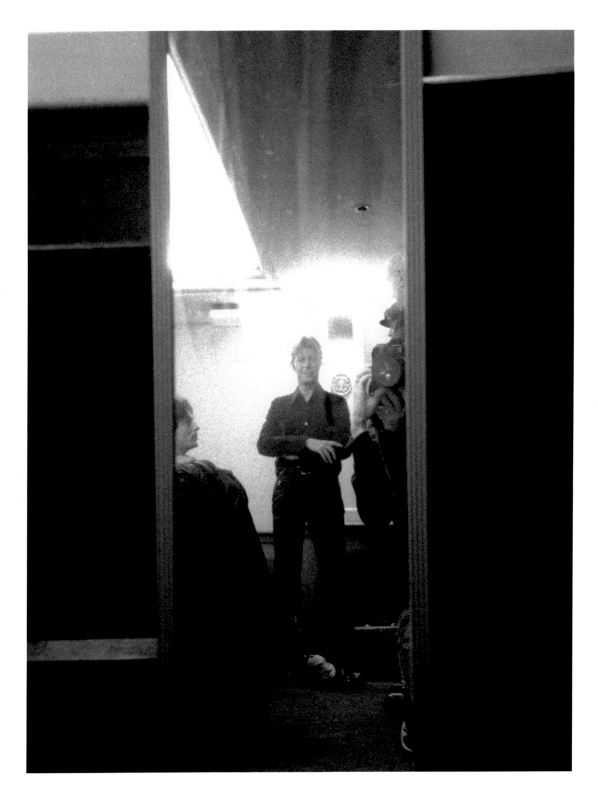

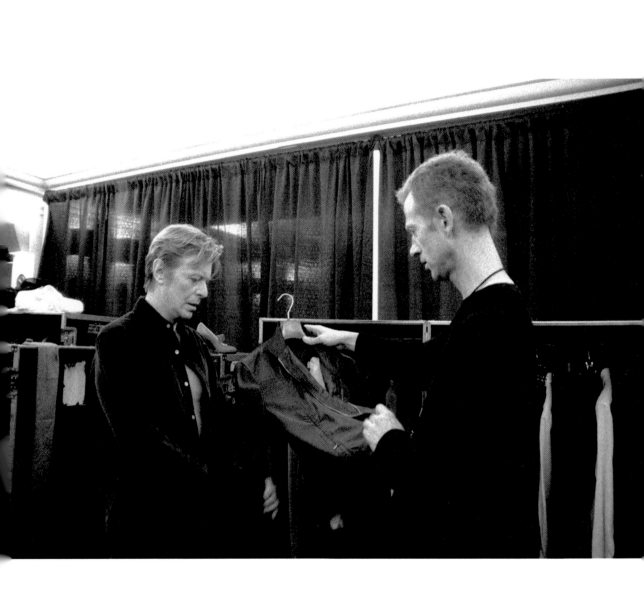

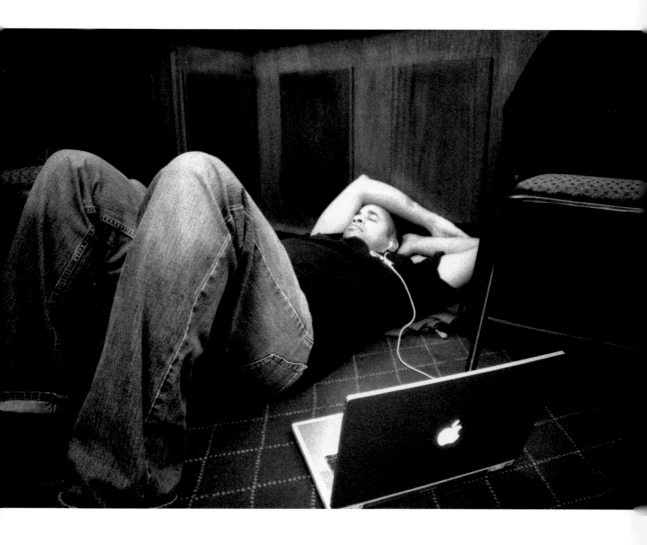

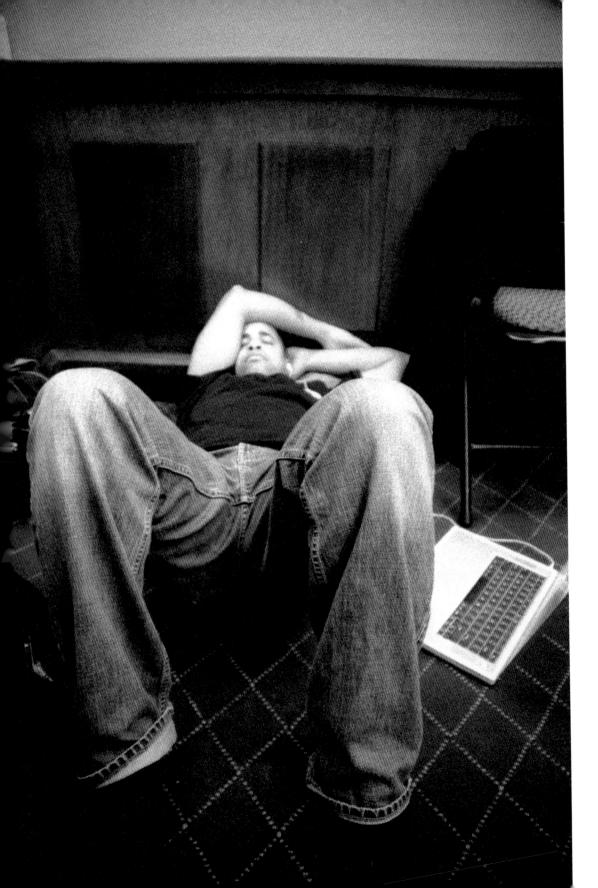

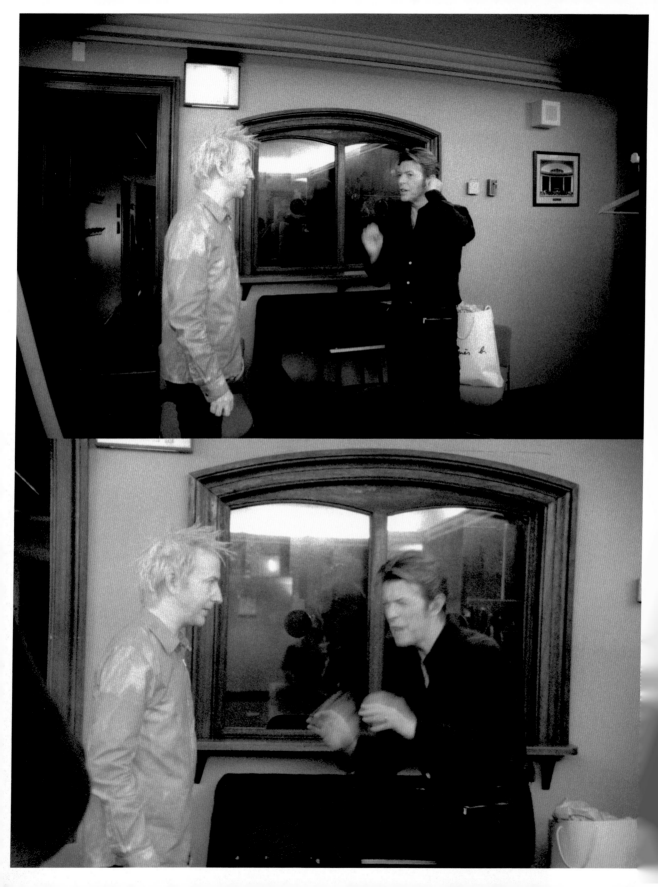

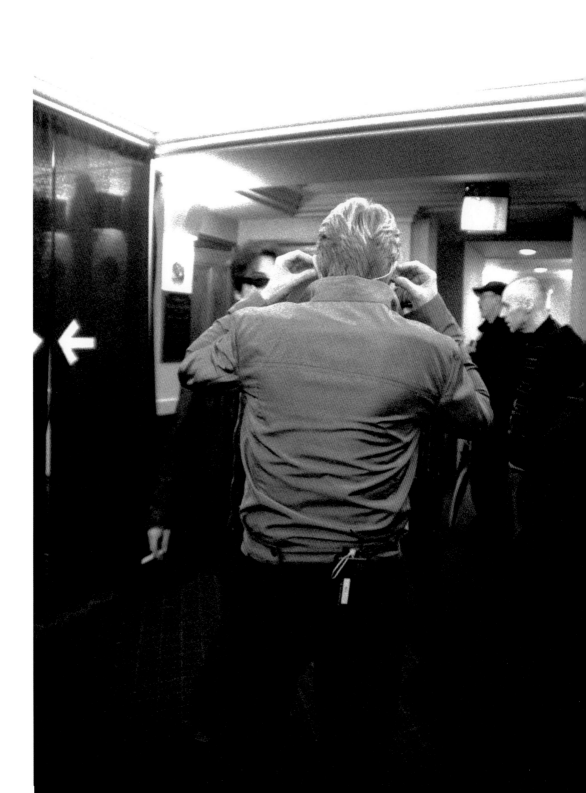

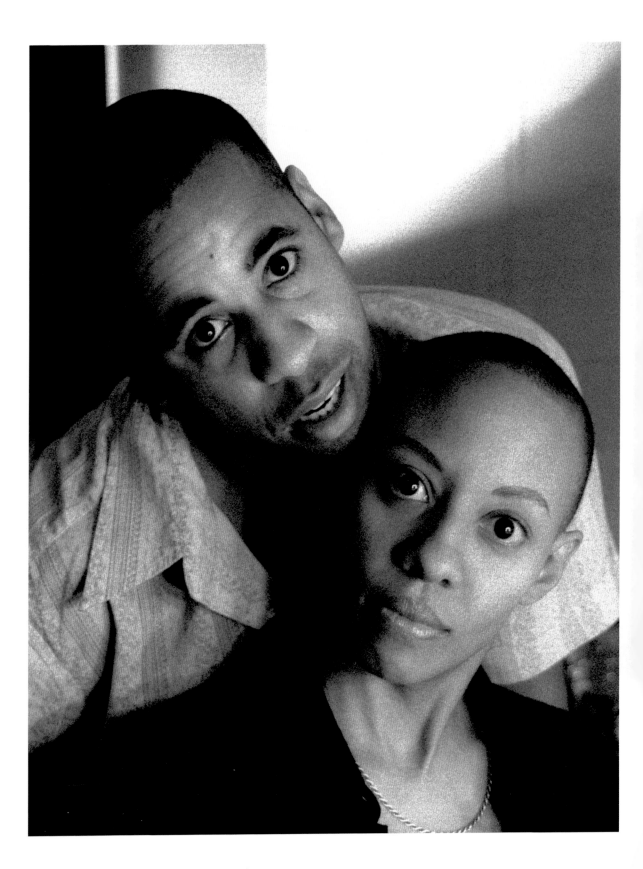

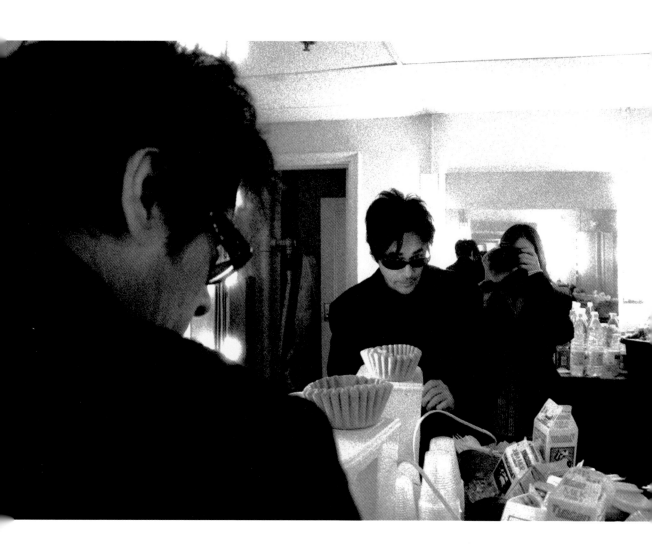

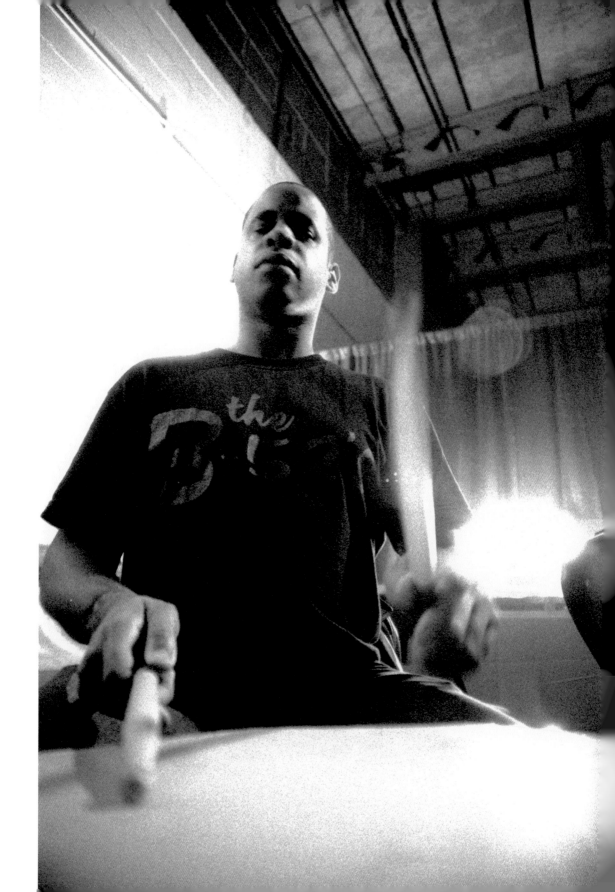

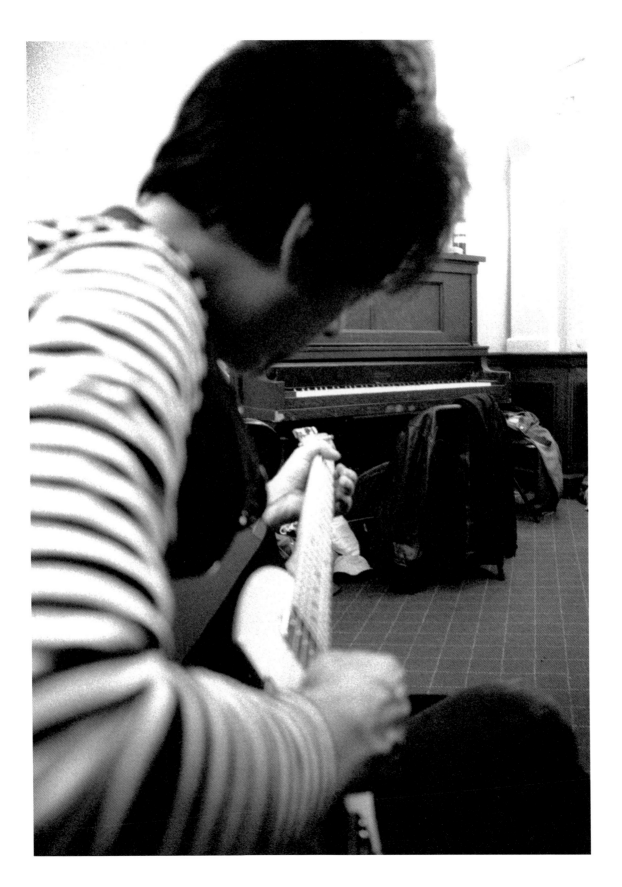

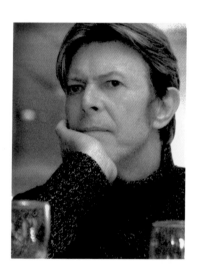

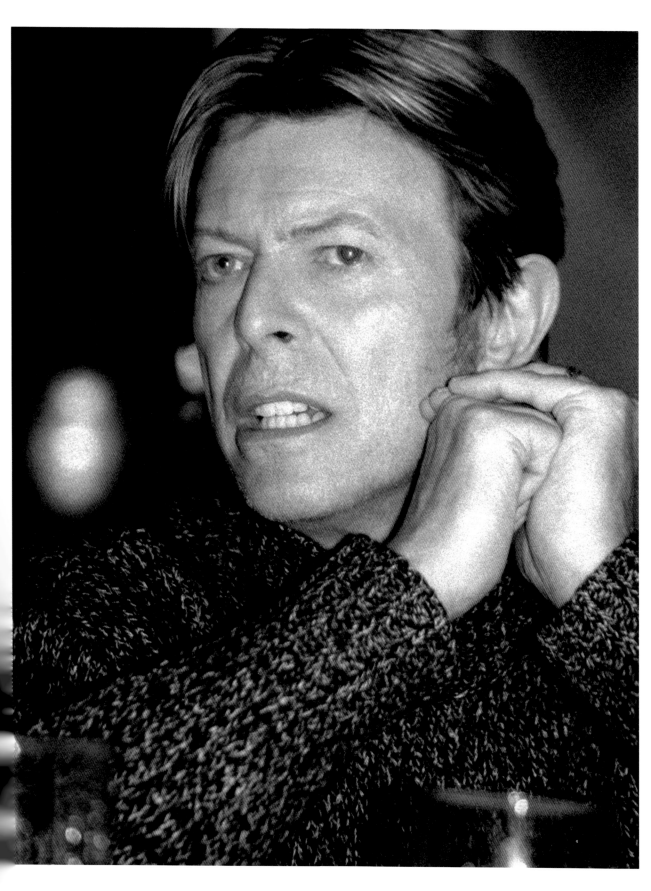

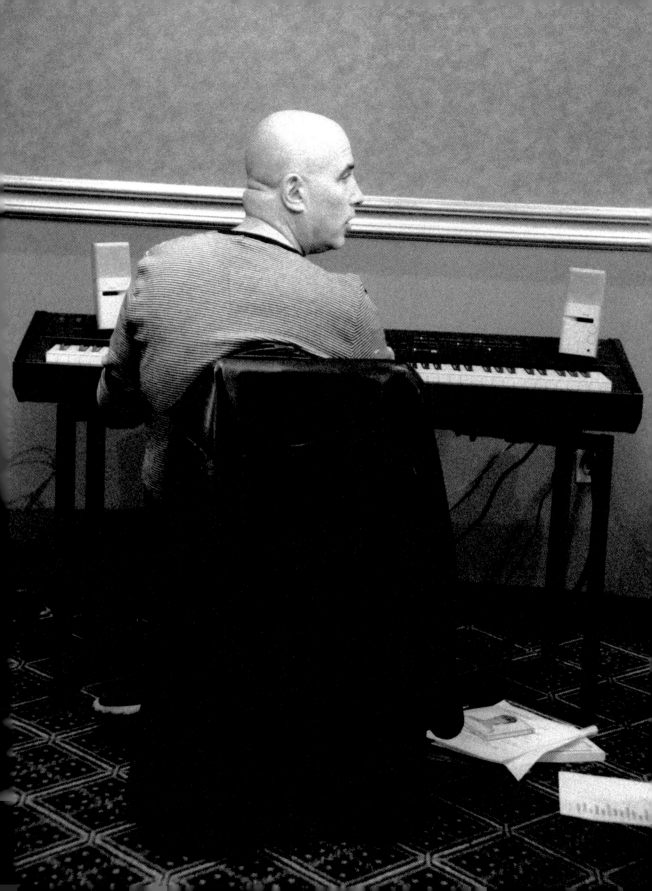

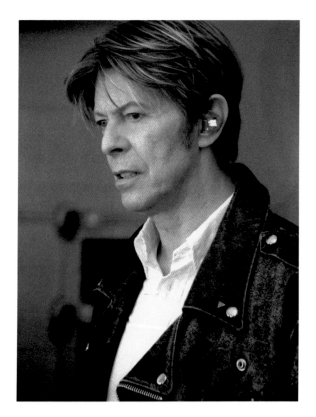
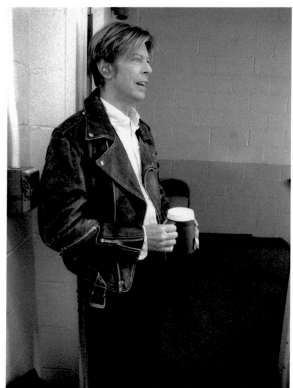

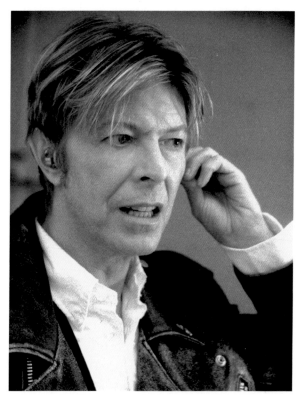

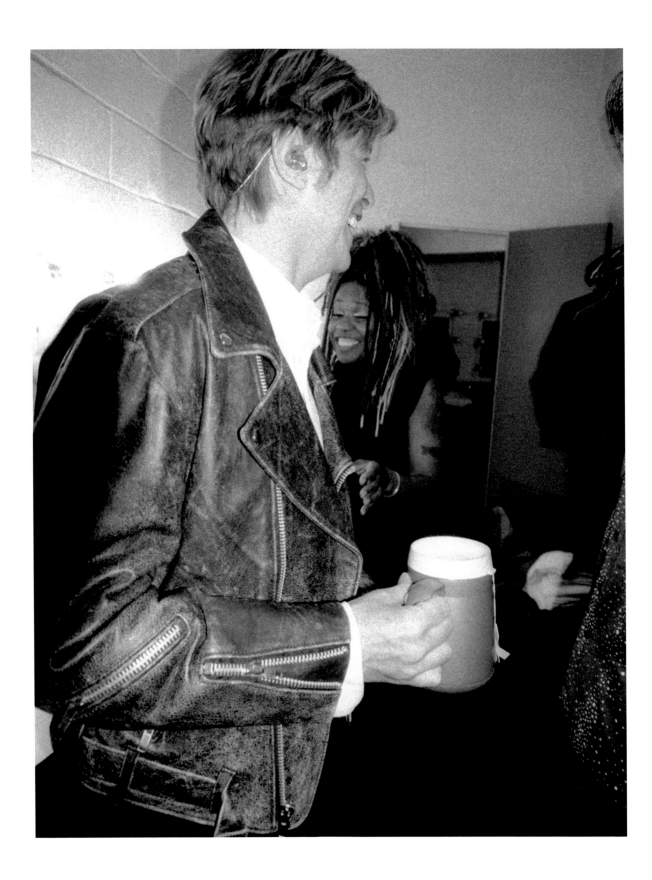

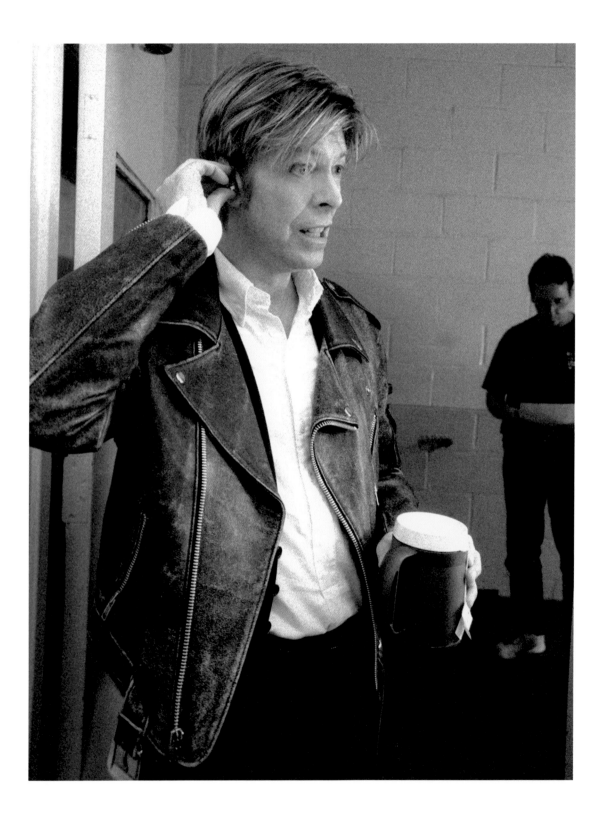

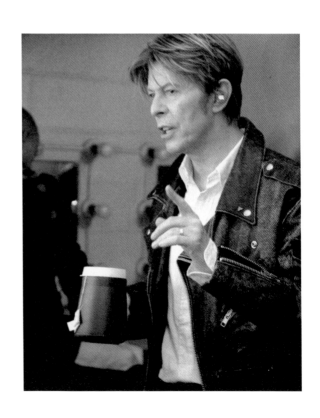

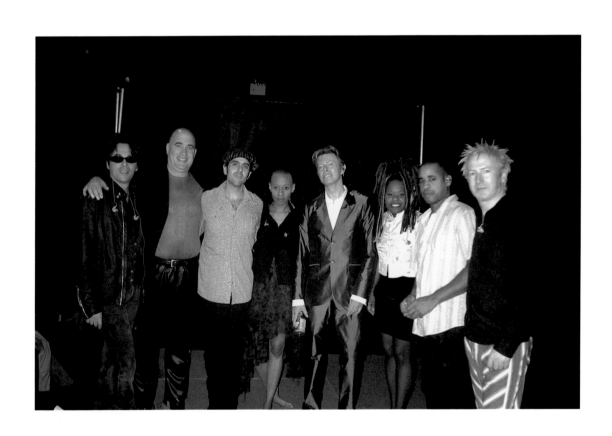

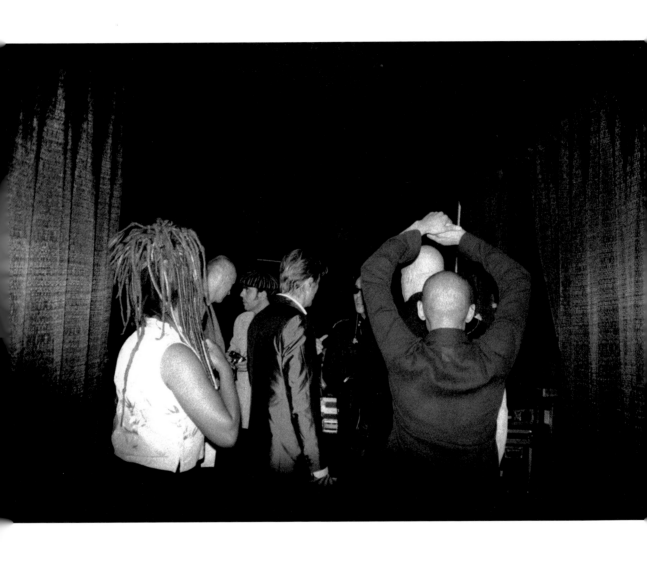

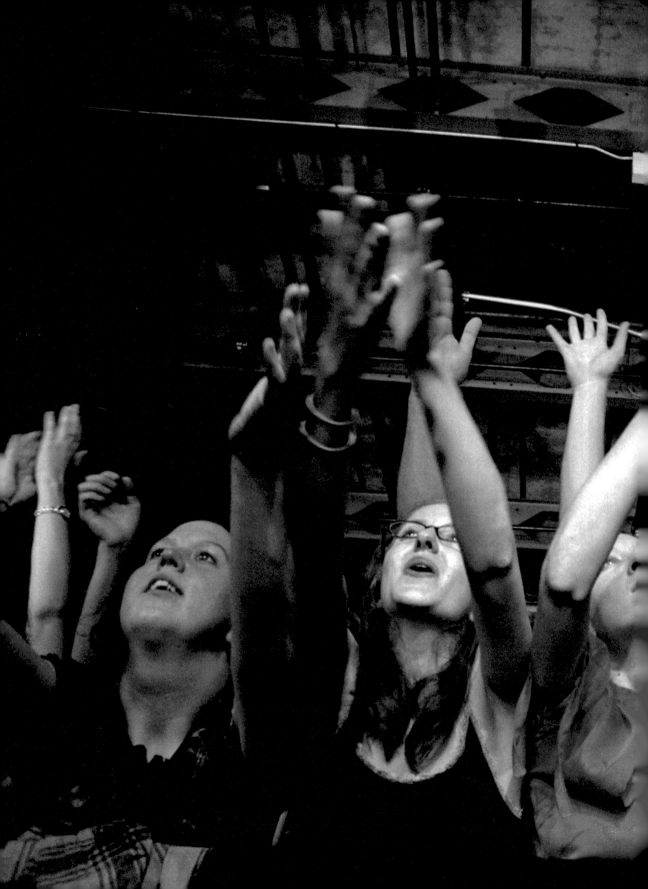

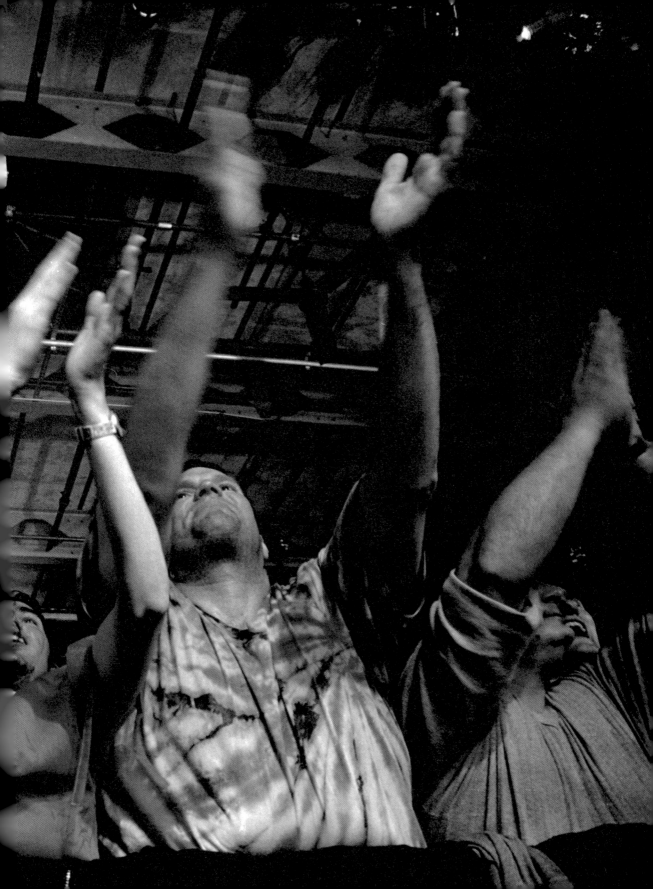

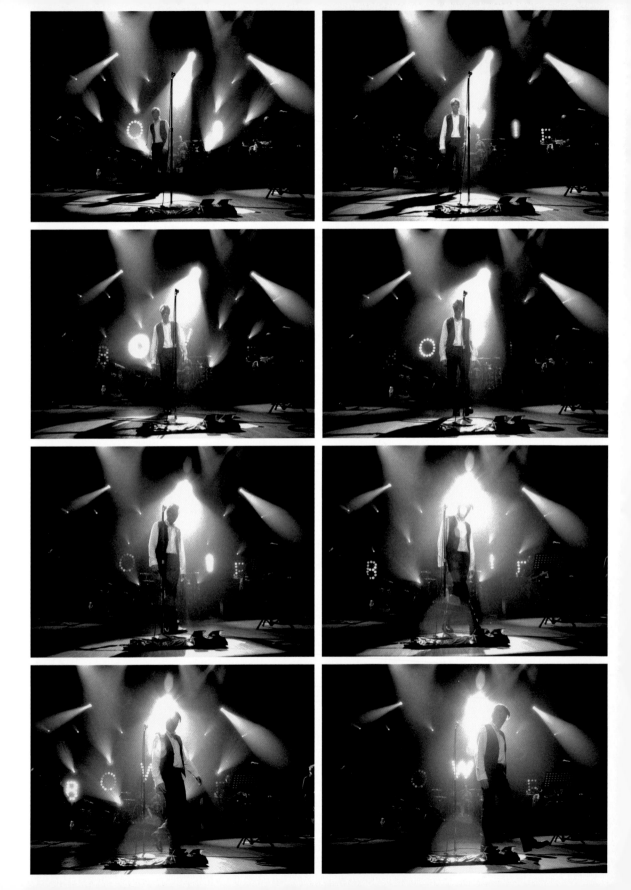

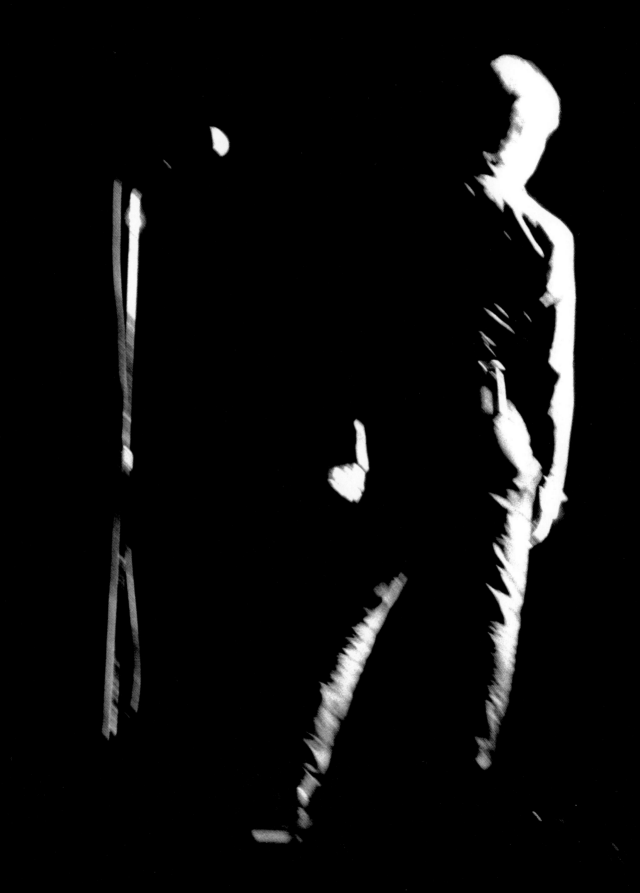

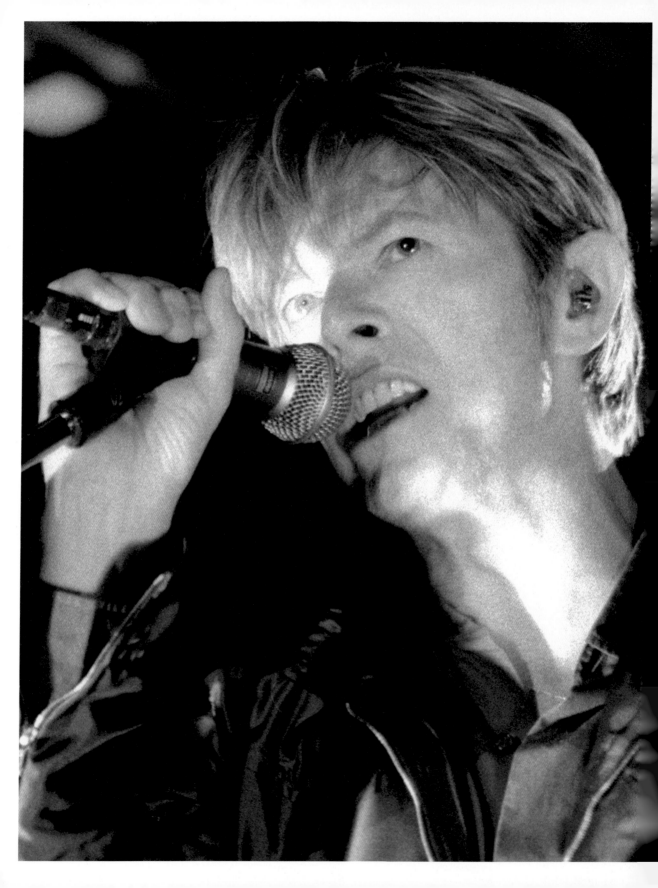

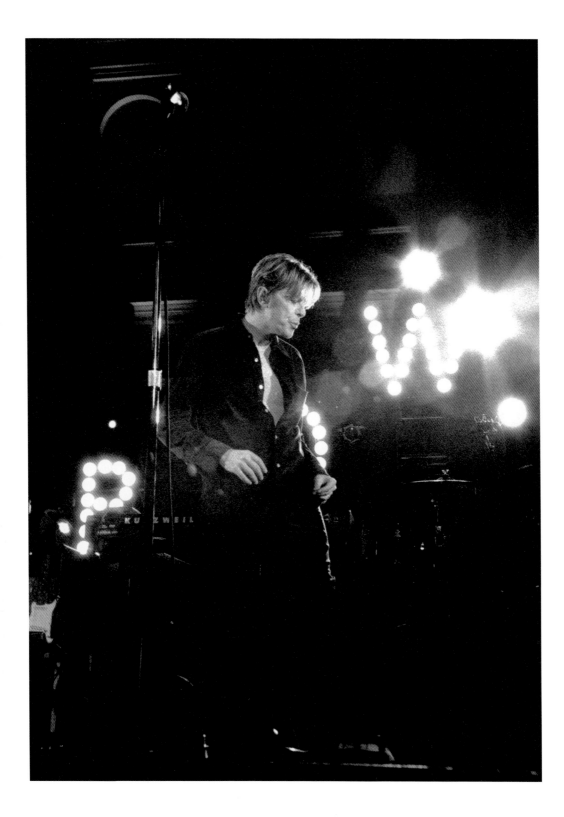

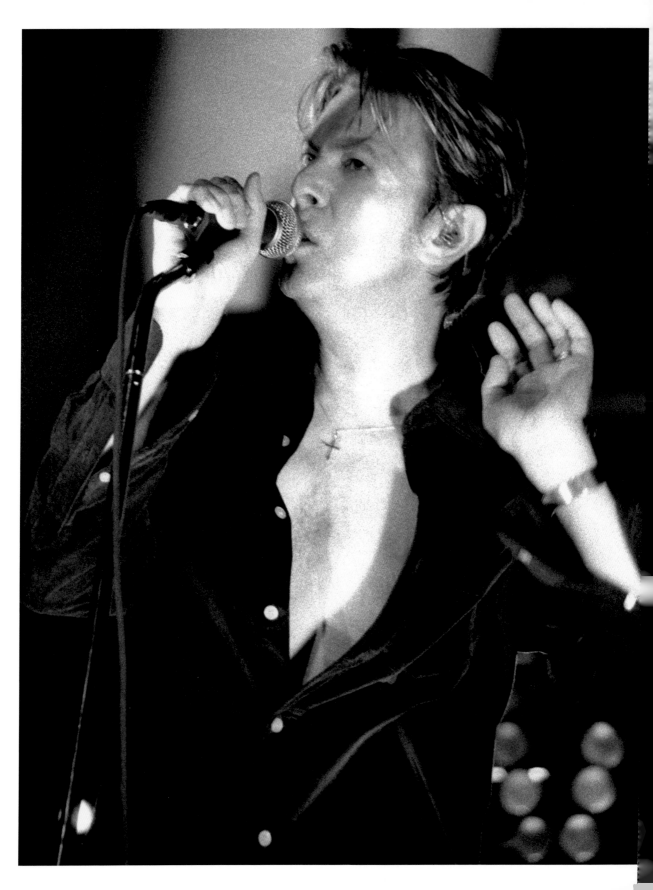

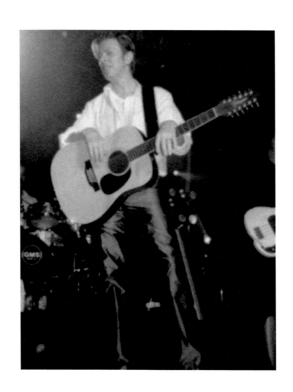

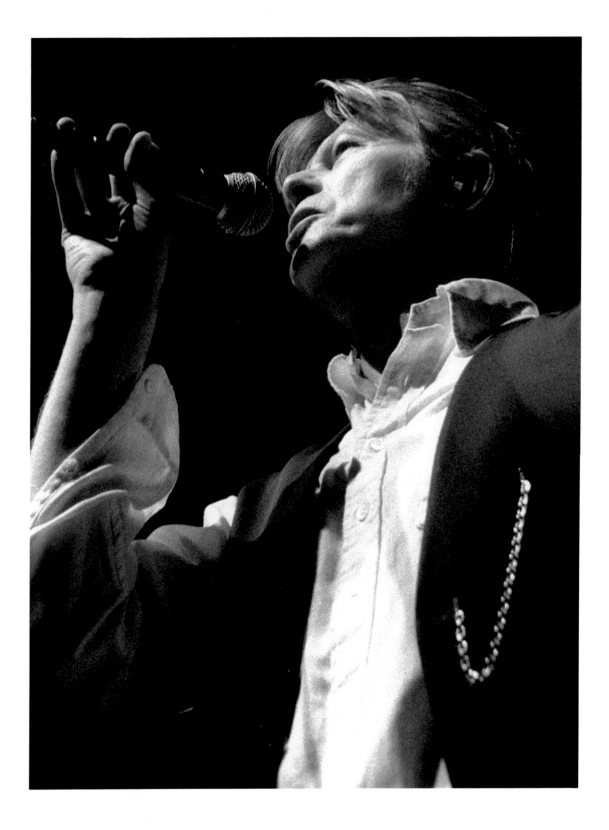

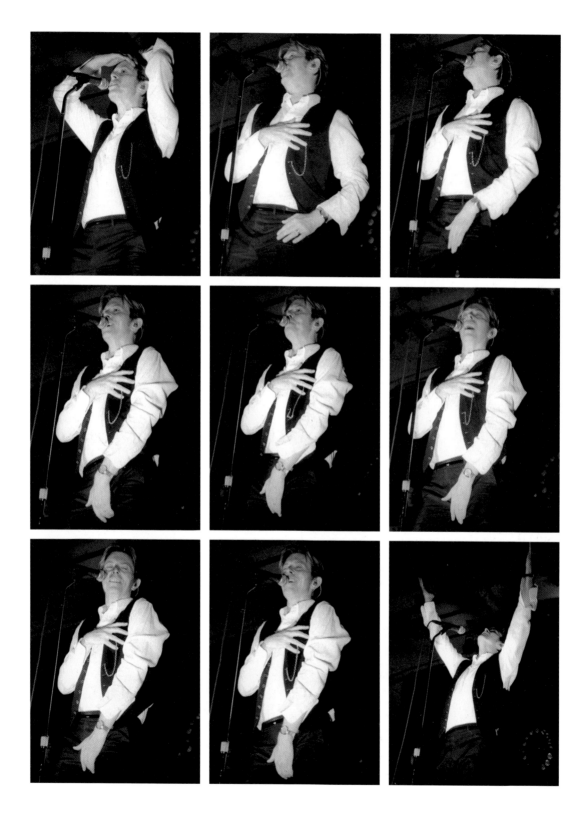

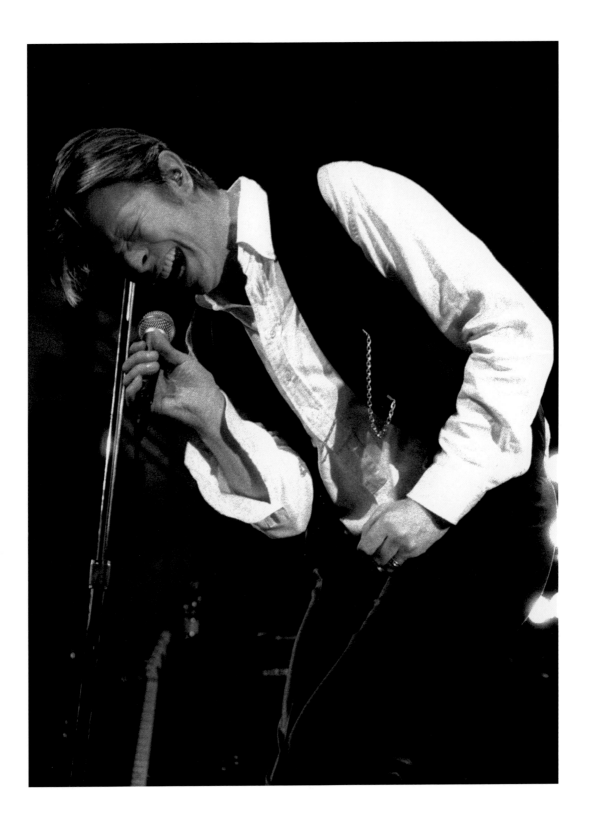

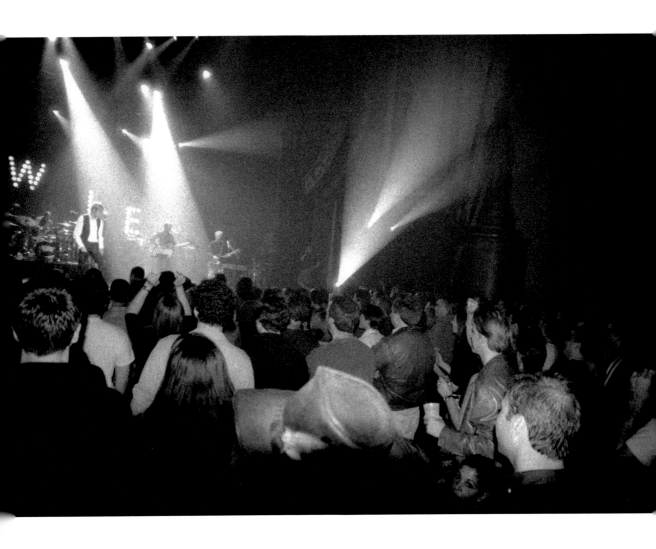

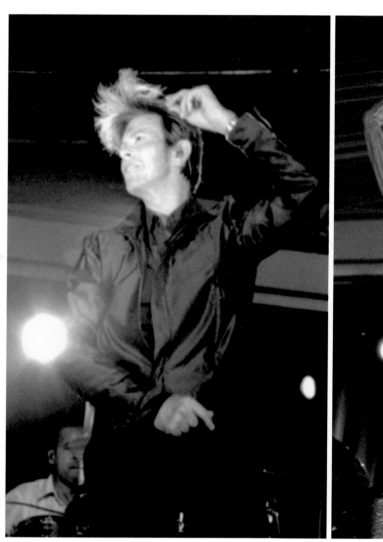
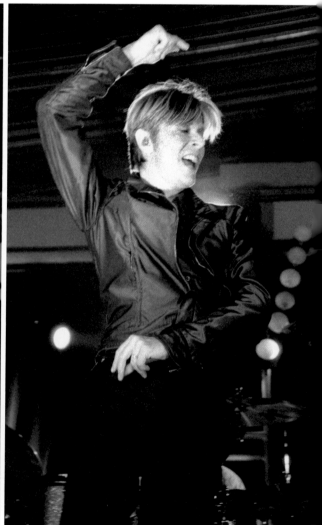

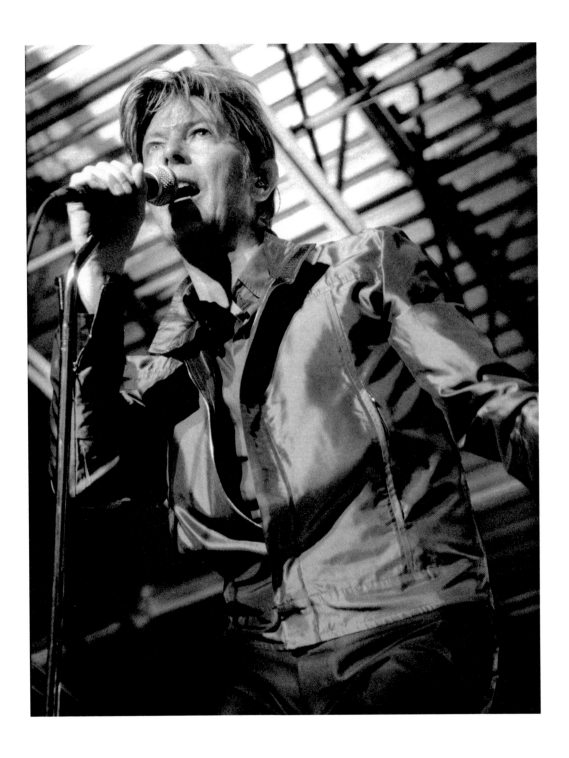

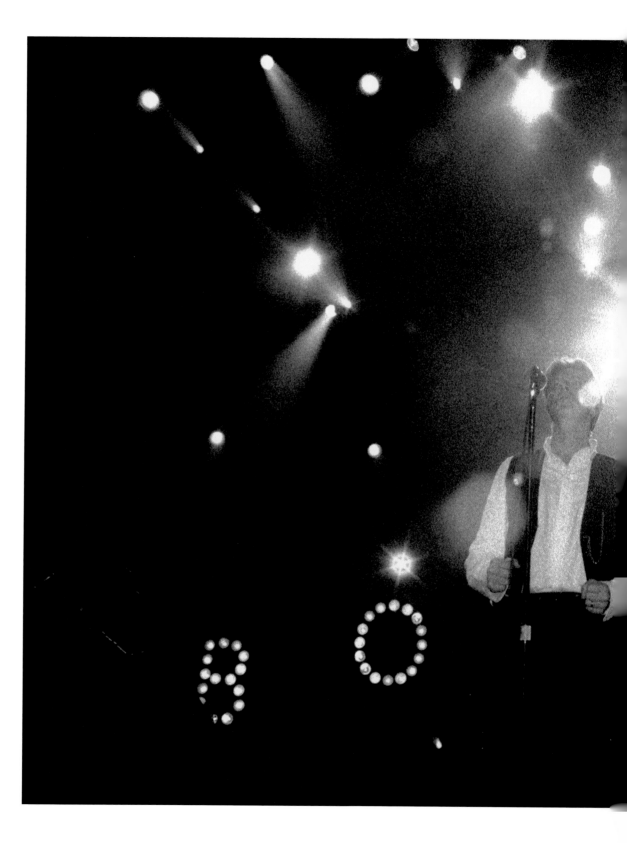

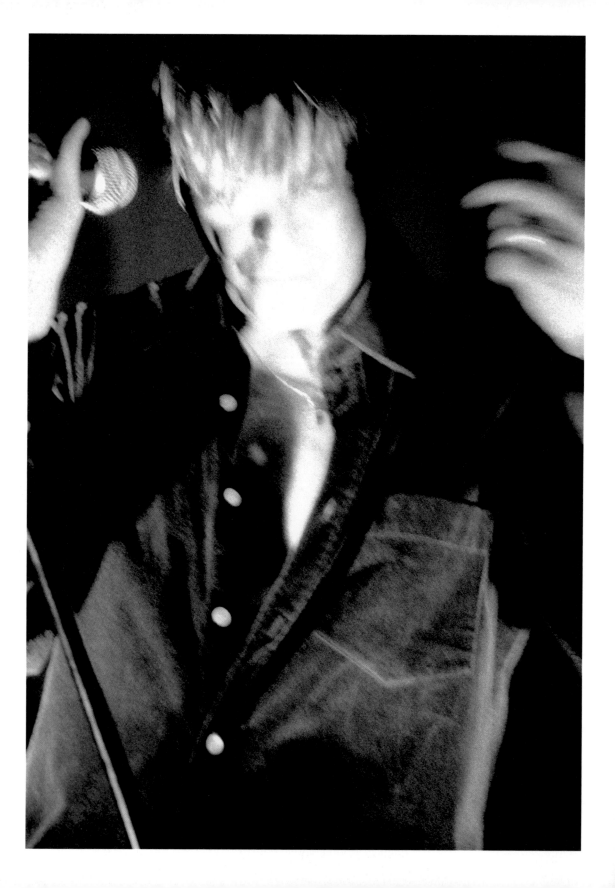

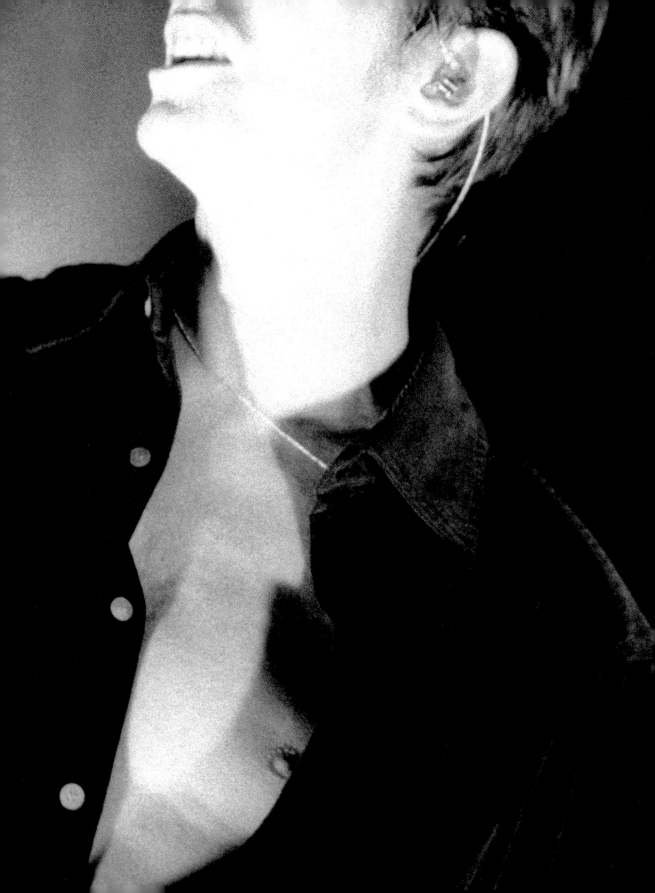

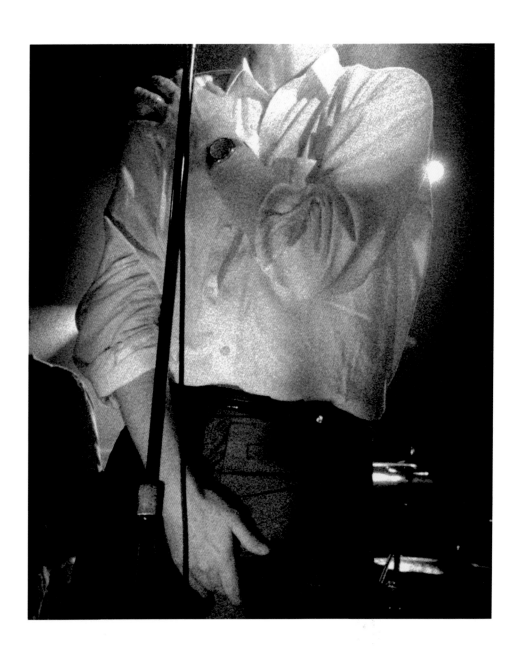

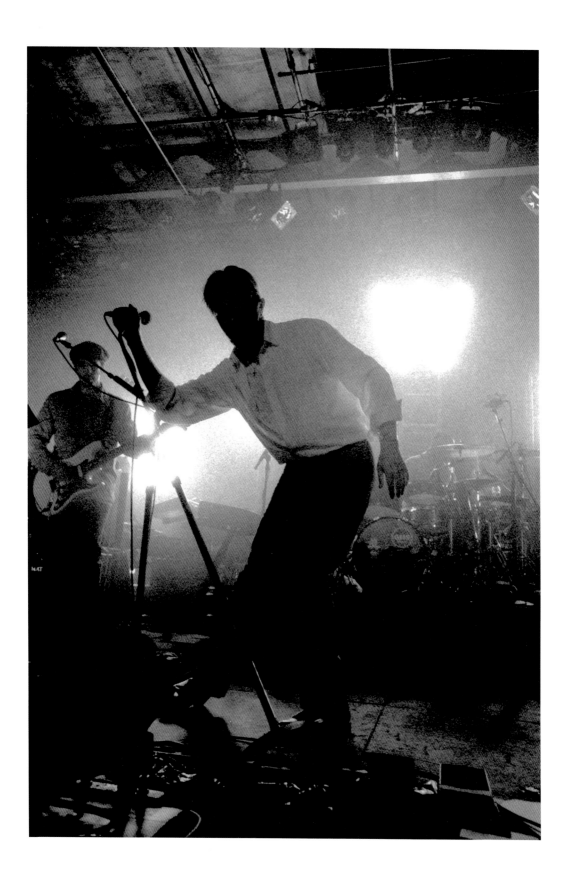

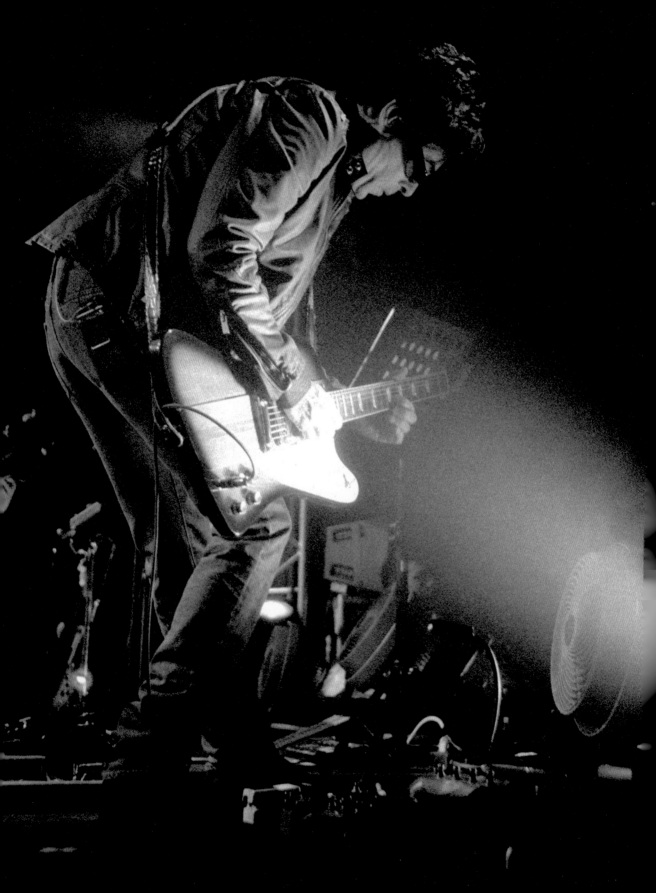

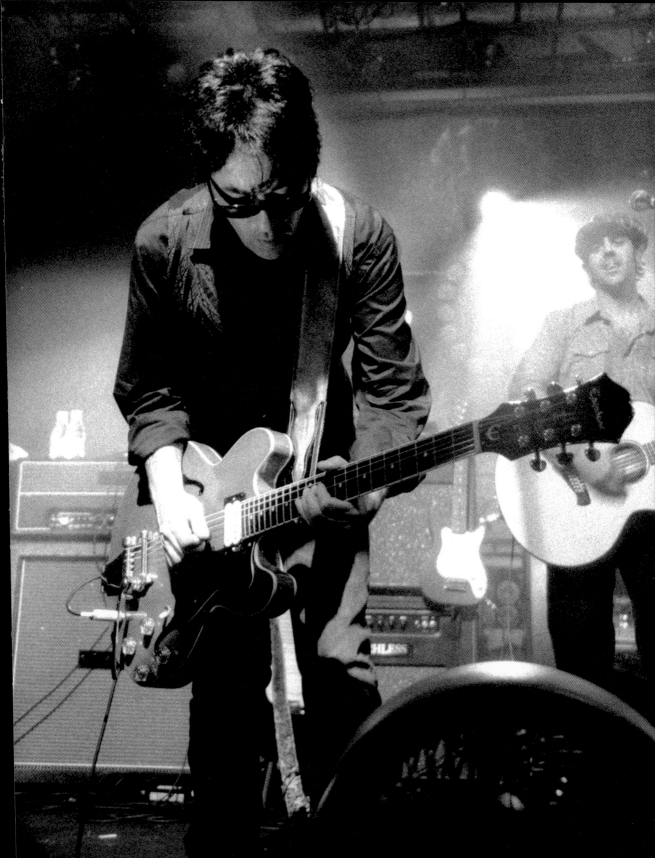

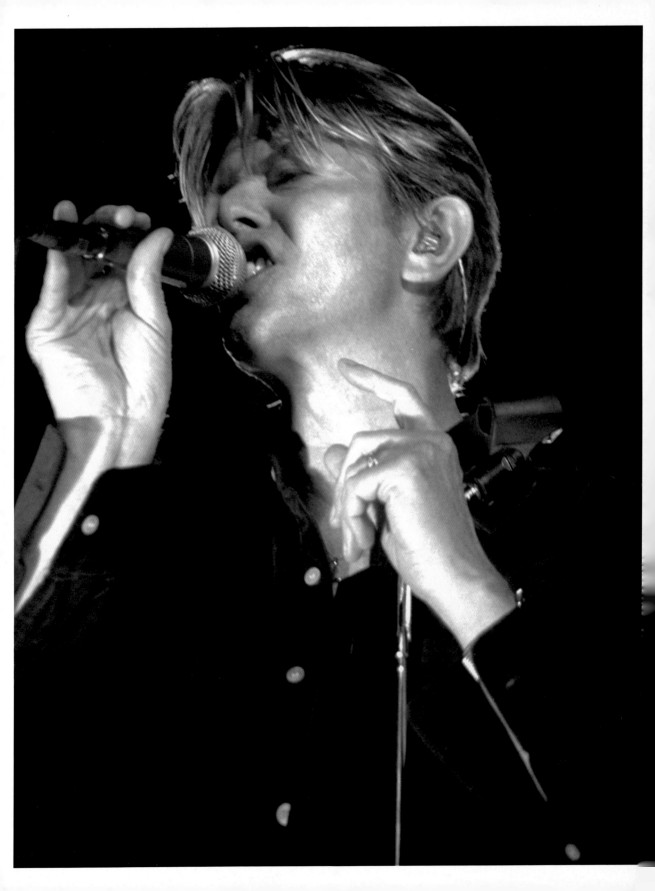

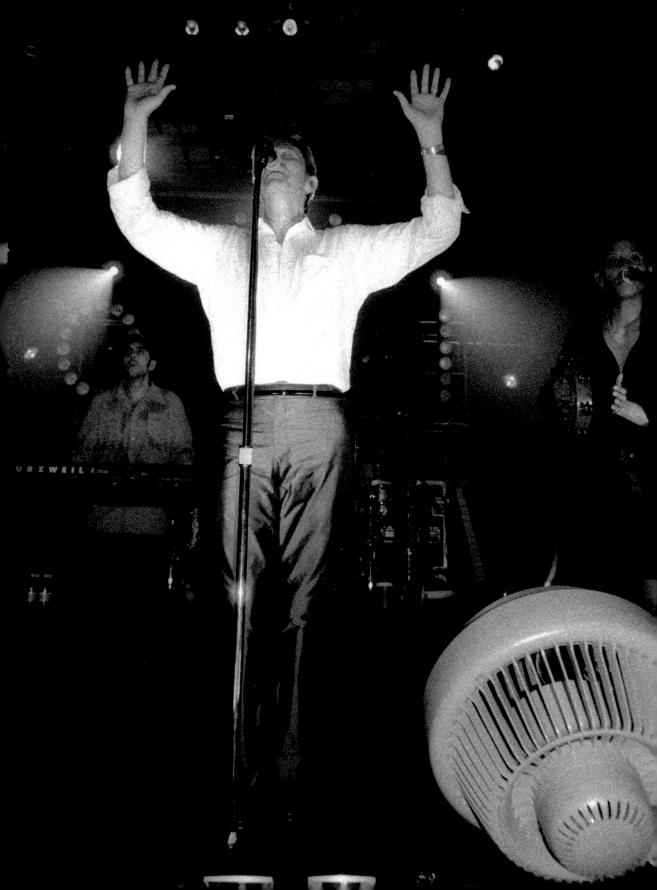

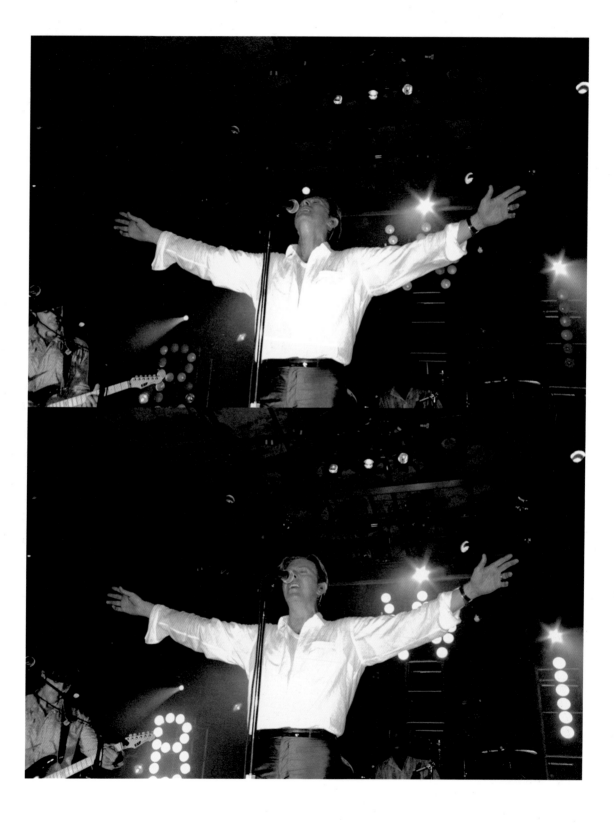

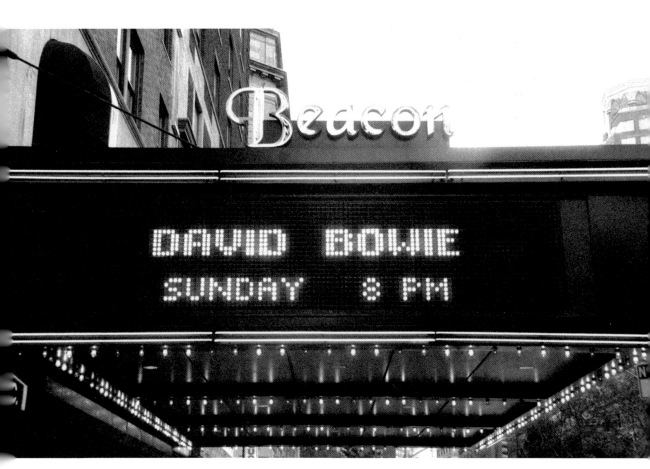

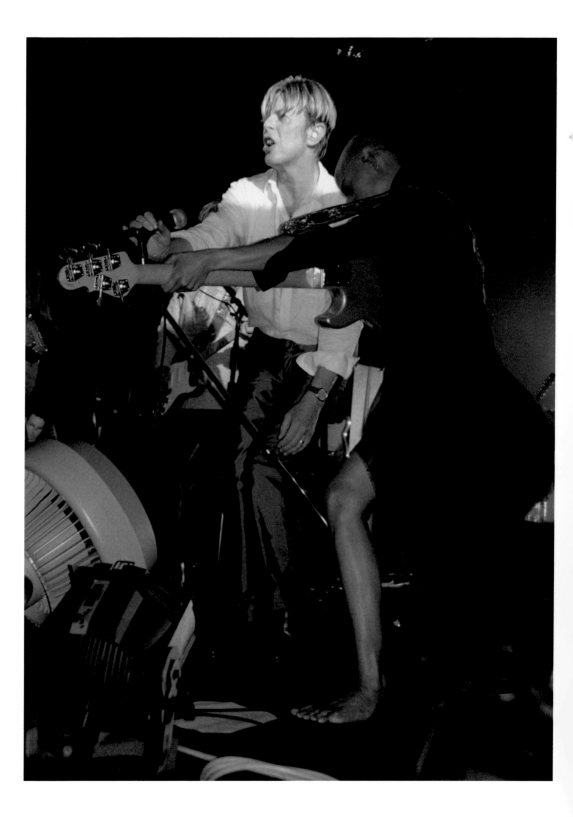

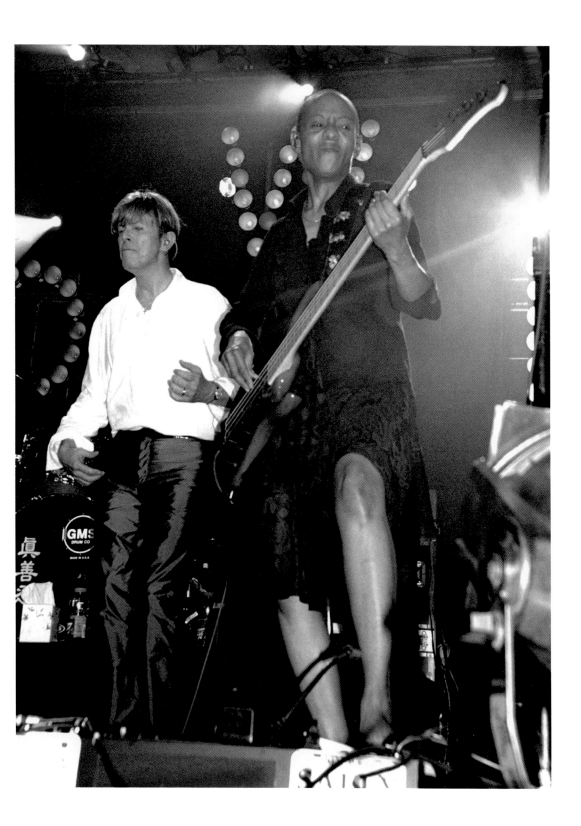

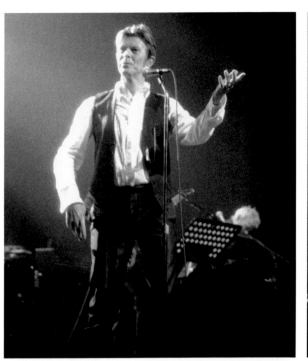
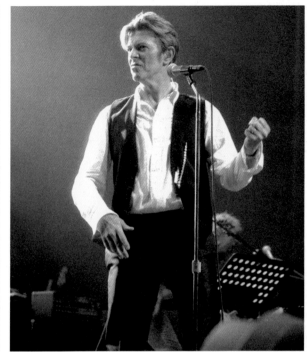
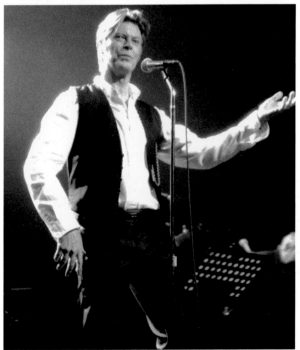
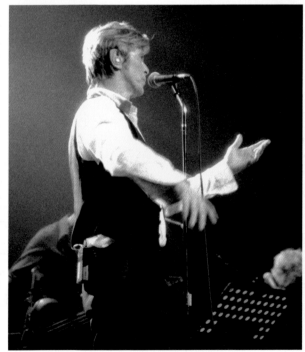

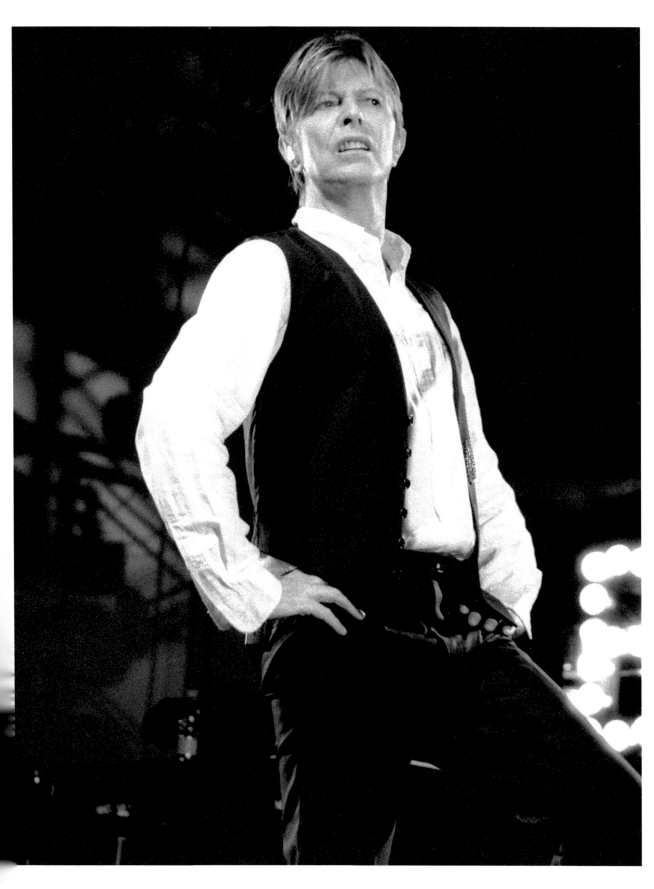

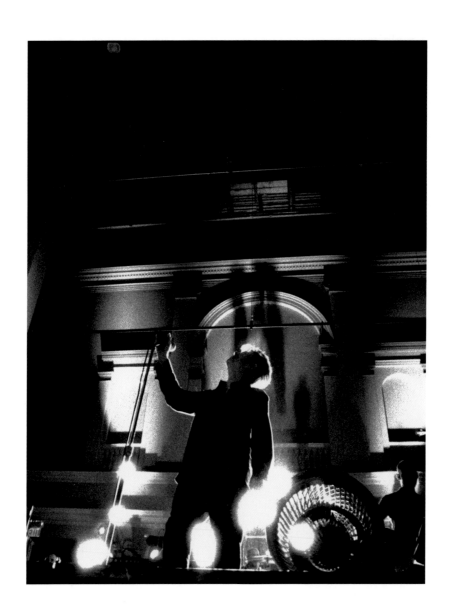

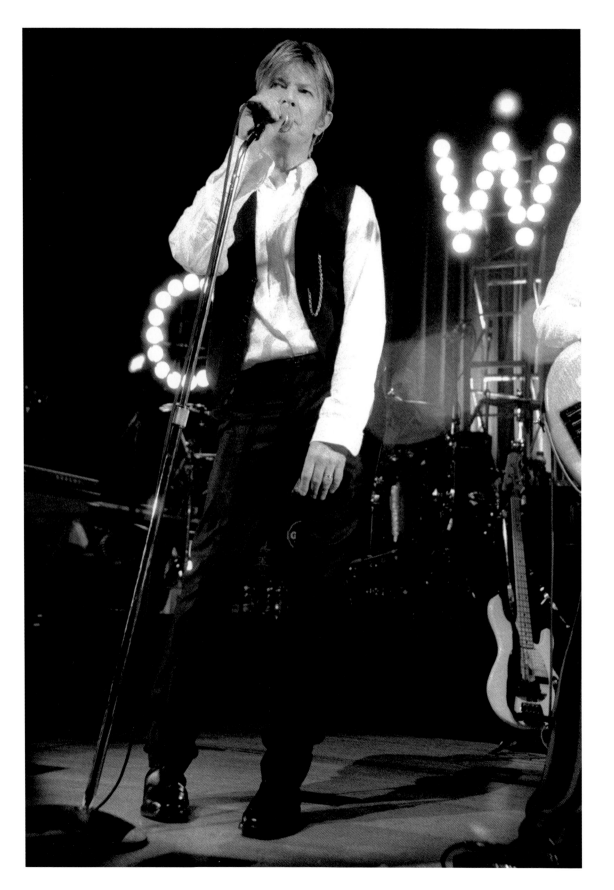

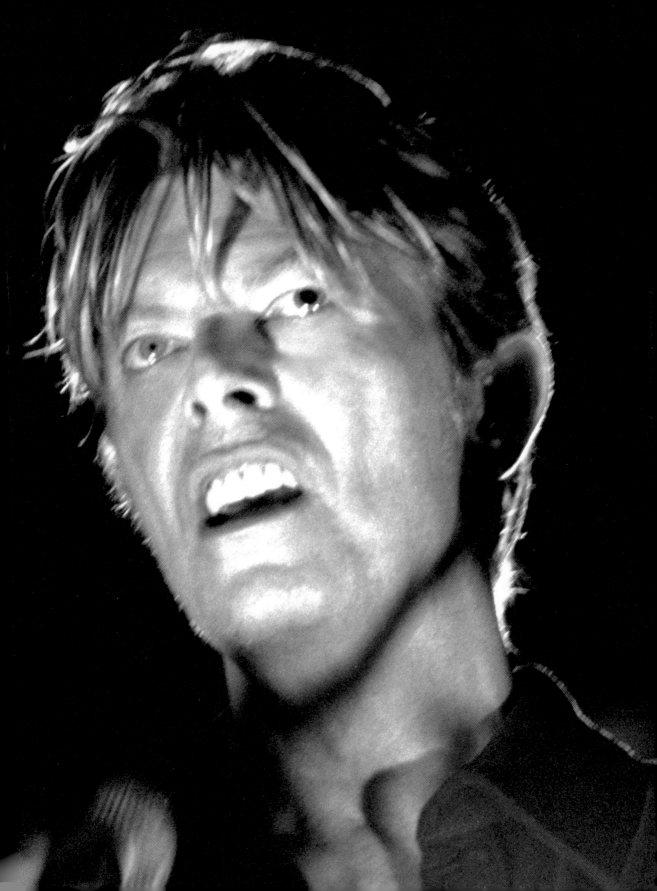

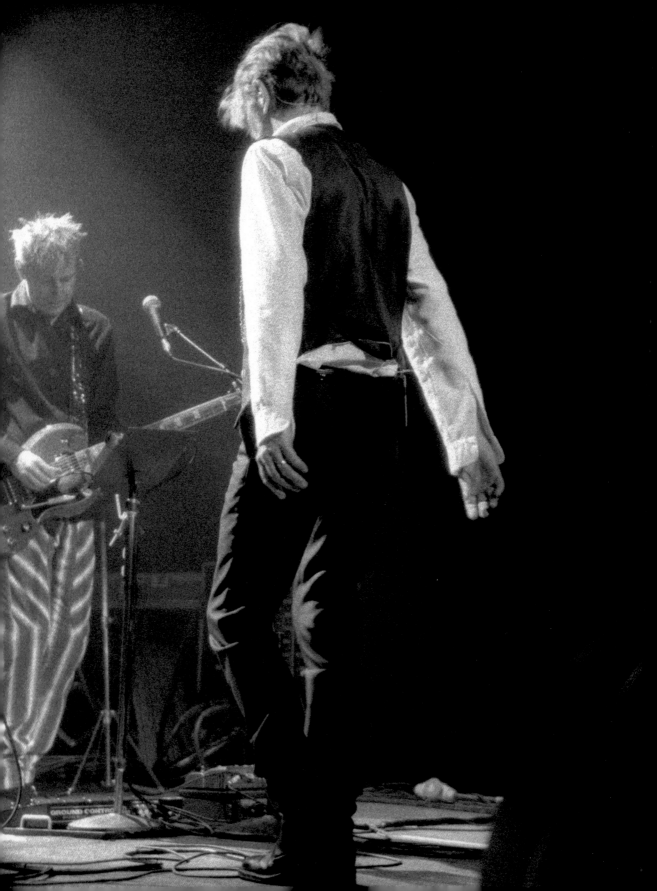

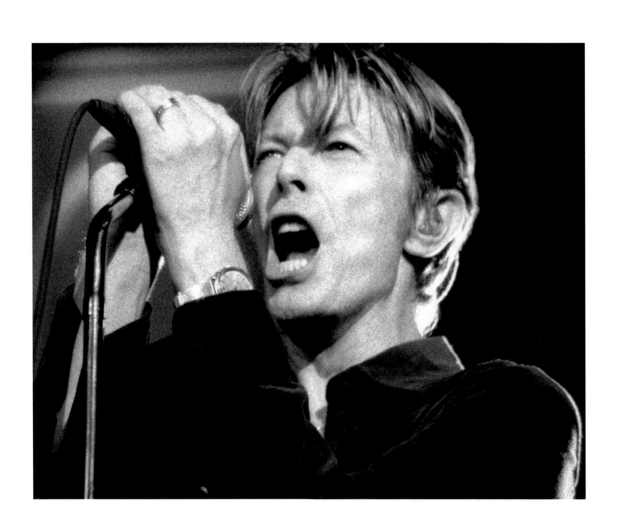

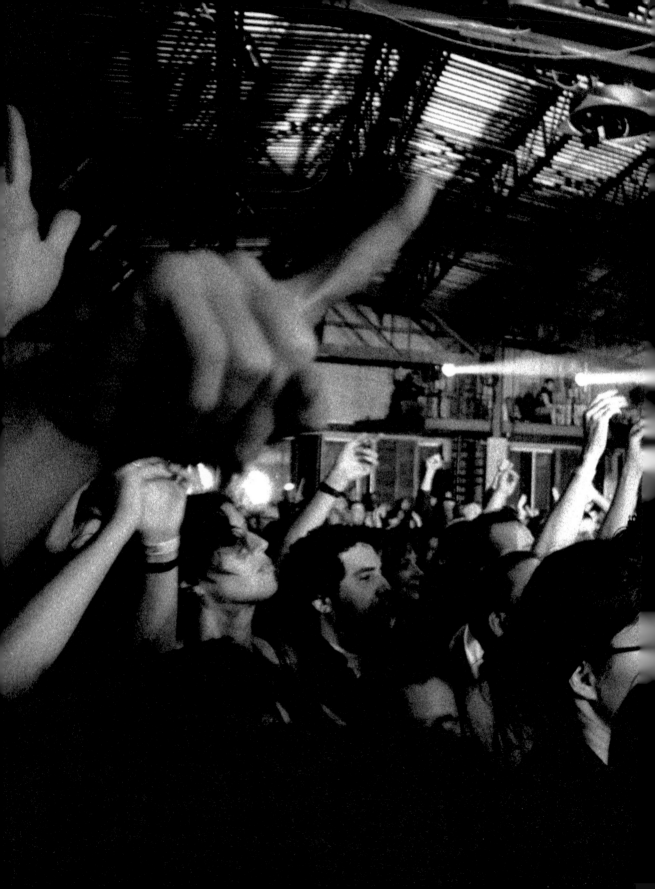

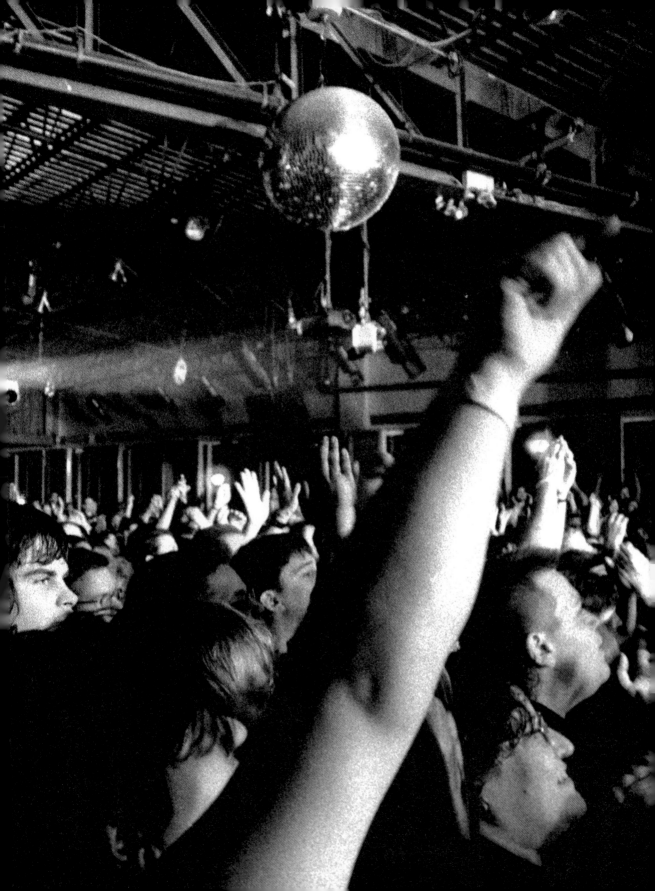

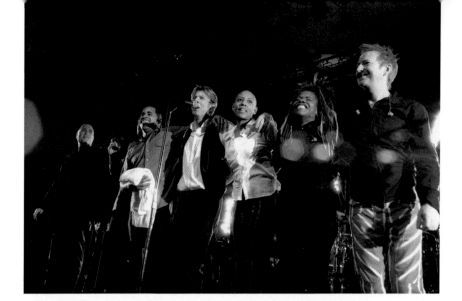

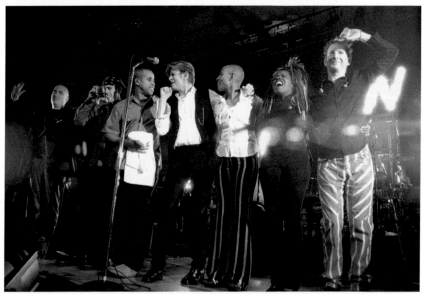

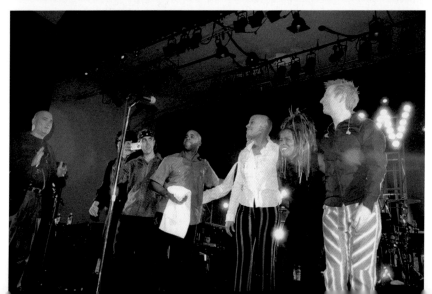

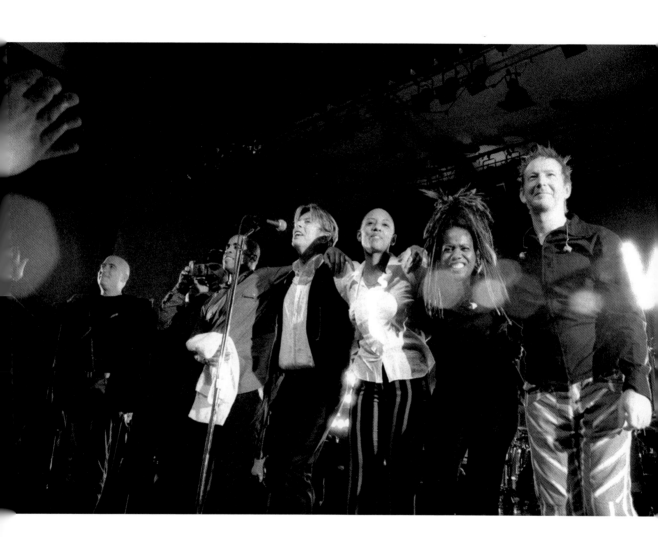

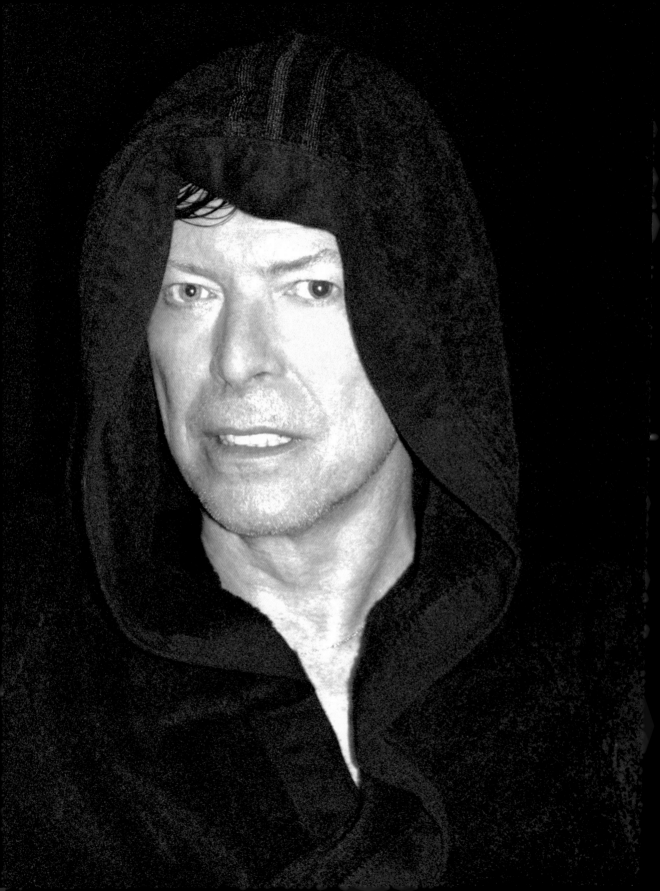

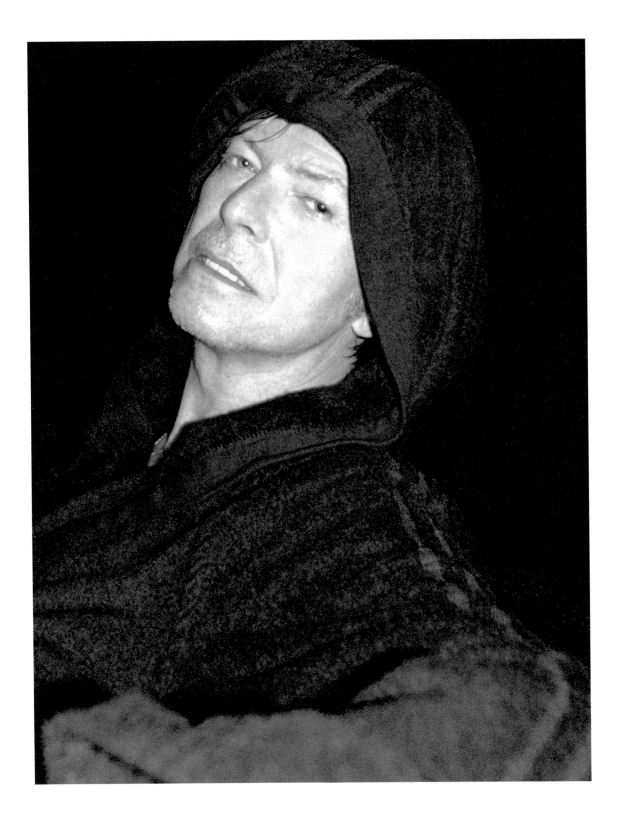

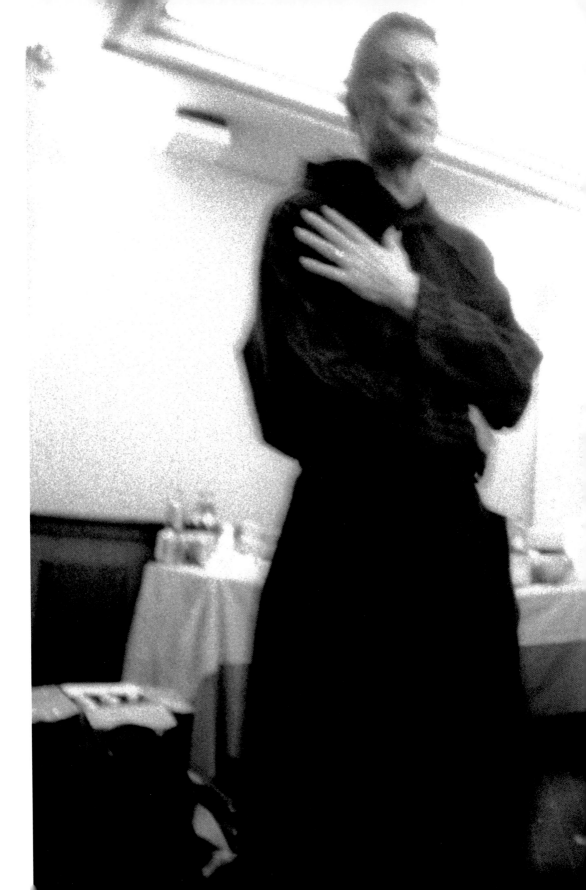

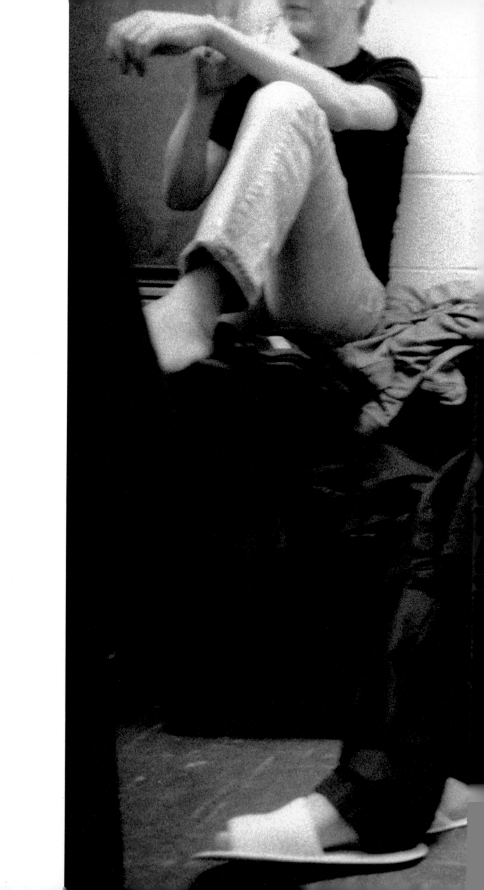

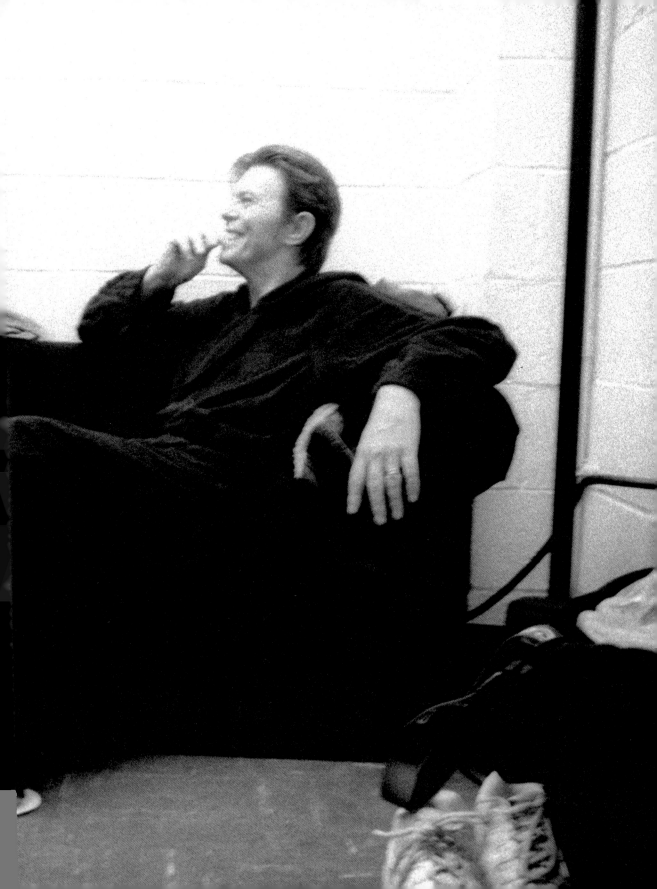

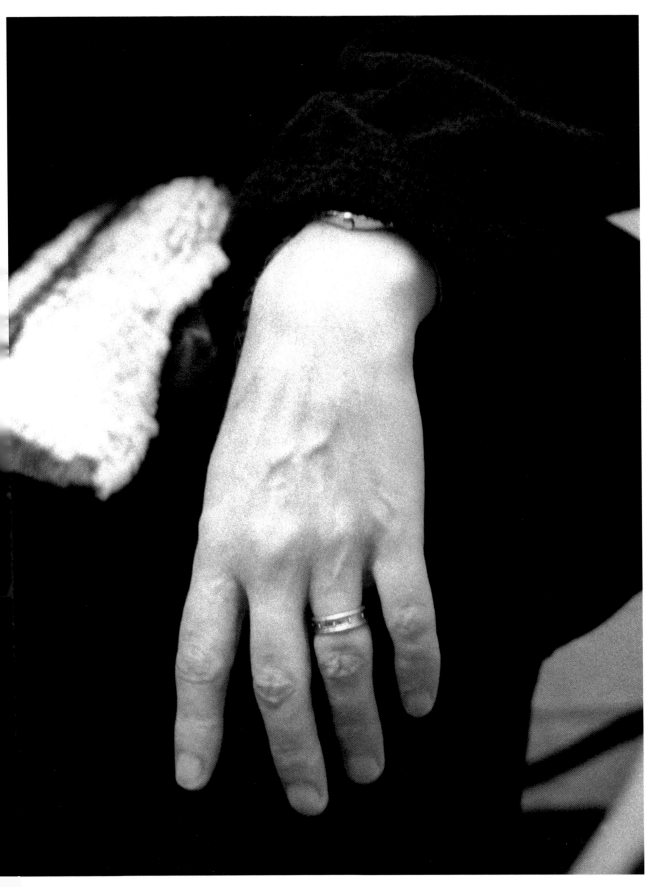

NYC BOWIE-THON

71

OCTOBER 2002

MARATHON PRINTING, INC • 800-255-4100 • www.marathonezone.com

OCTOBER 11, 2002
STATEN ISLAND
THE MUSIC HALL AT SNUG HARBOR

LIFE ON MARS?
ASHES TO ASHES
BREAKING GLASS
CACTUS
CHINA GIRL
SLIP AWAY
FAME
I'M AFRAID OF AMERICANS
SPEED OF LIFE
5:15 THE ANGELS HAVE GONE
I'VE BEEN WAITING FOR YOU
SURVIVE
REBEL REBEL
"HEROES"
HEATHEN (THE RAYS)

ENCORE:
SUNDAY
I WOULD BE YOUR SLAVE
AFRAID
EVERYONE SAYS "HI"
HALLO SPACEBOY
LET'S DANCE
ZIGGY STARDUST

OCTOBER 12, 2002
BROOKLYN
ST. ANN'S WAREHOUSE

SUNDAY
CACTUS
BREAKING GLASS
FAME
ASHES TO ASHES
SLIP AWAY
CHINA GIRL
5:15 THE ANGELS HAVE GONE
SURVIVE
I'VE BEEN WAITING FOR YOU
REBEL REBEL
I'M AFRAID OF AMERICANS
LIFE ON MARS?
LOOK BACK IN ANGER
"HEROES"
HEATHEN (THE RAYS)

ENCORE:
MOONAGE DAYDREAM
AFRAID
STAY
BEWLAY BROTHERS
EVERYONE SAYS "HI"
HALLO SPACEBOY
LET'S DANCE
ZIGGY STARDUST

OCTOBER 16, 2002
QUEENS
COLDEN CENTER AT QUEENS COLLEGE

SUNDAY
CACTUS
BREAKING GLASS
FAME
ASHES TO ASHES
SLIP AWAY
CHINA GIRL
5:15 THE ANGELS HAVE GONE
STARMAN
CHANGES
ABSOLUTE BEGINNERS
I'VE BEEN WAITING FOR YOU
AFRAID
FASHION
BE MY WIFE
SOUND AND VISION
REBEL REBEL
I'M AFRAID OF AMERICANS
LIFE ON MARS?
"HEROES"
HEATHEN (THE RAYS)

ENCORE:
WHITE LIGHT/WHITE HEAT
LET'S DANCE
HALLO SPACEBOY
ZIGGY STARDUST

OCTOBER 17, 2002
BRONX
JIMMY'S BRONX CAFE

SUNDAY
CACTUS
BREAKING GLASS
FAME
ASHES TO ASHES
SLIP AWAY
CHINA GIRL
5:15 THE ANGELS HAVE GONE
STARMAN
ABSOLUTE BEGINNERS
I'VE BEEN WAITING FOR YOU
AFRAID
FASHION
BE MY WIFE
SOUND AND VISION
REBEL REBEL
I'M AFRAID OF AMERICANS
LIFE ON MARS?
"HEROES"
HEATHEN (THE RAYS)

ENCORE:
WHITE LIGHT/WHITE HEAT
LET'S DANCE
ZIGGY STARDUST

OCTOBER 20, 2002
MANHATTAN
BEACON THEATER

SUNDAY
CACTUS
BREAKING GLASS
FAME
ASHES TO ASHES
SLIP AWAY
CHINA GIRL
5:15 THE ANGELS HAVE GONE
STARMAN
ABSOLUTE BEGINNERS
I'VE BEEN WAITING FOR YOU
AFRAID
FASHION
BE MY WIFE
SOUND AND VISION
REBEL REBEL
I'M AFRAID OF AMERICANS
LIFE ON MARS?
"HEROES"
HEATHEN (THE RAYS)

ENCORE:
WHITE LIGHT/WHITE HEAT
LET'S DANCE
ZIGGY STARDUST

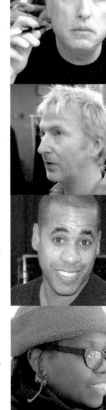

MIKE GARSON

GERRY LEONARD

STERLING CAMPBELL

CATHERINE RUSSELL

GAIL ANN DORSEY

EARL SLICK

MARK PLATI

COCO SCHWAB

SPECIAL THANKS FIRST AND FOREMOST TO DAVID BOWIE FOR NOT
ONLY HIS TRUST AND THE ACCESS TO CREATE THESE PHOTOGRAPHS,
BUT ALSO FOR BEING A CONSTANT SOURCE OF INSPIRATION.

THANK YOU TO AMY SCHOLDER FOR HER BRILLIANCE AS AN EDITOR,
AND FOR HER SUPPORT THROUGHOUT EACH STEP OF THE PROCESS.

THANK YOU TO REX RAY FOR MAKING MY IMAGES COME ALIVE
WITH HIS BEAUTIFUL DESIGN.

MANY THANKS TO NORMAN WONDERLY FOR EVERYTHING.

A SPECIAL THANKS TO ELIZABETH RYAN AND DEREK DONOVAN
FOR THEIR INVALUABLE SUPPORT.

THANK YOU TO EILEEN D'ARCY AND BILL ZYSBLAT FOR THEIR
PATIENCE AND KINDNESS.

THANK YOU TO JANINE GEVAS FOR GIVING ME THE ROOM TO
GROW AS AN ARTIST.

THANK YOU TO EVERYONE AT POWERHOUSE BOOKS.

THE MOST SPECIAL OF THANKS TO MY BOYS, ALEX AND ETHAN.

—MYRIAM SANTOS-KAYDA

MYRIAM SANTOS-KAYDA
HAS BEEN A PORTRAIT PHOTOGRAPHER
FOR THE MUSIC AND ENTERTAINMENT INDUSTRY
FOR THE PAST TEN YEARS. IN ADDITION TO
DAVID BOWIE, SHE HAS WORKED WITH
TRENT REZNOR, MARILYN MANSON,
TOOL, GARBAGE, BEN HARPER, DAVID GRAY,
LISA KUDROW, BILLY BOB THORNTON, TRICKY,
SYSTEM OF A DOWN, INCUBUS, AND ROB ZOMBIE, AMONG OTHERS.
HER WORK HAS APPEARED IN
*ROLLING STONE, DETOUR, SPIN, UNCUT,
ENTERTAINMENT WEEKLY, Q, ALTERNATIVE
PRESS*, AND *NEW YORK* MAGAZINE.
HER RECORD LABEL CLIENTS INCLUDE CAPITOL,
HOLLYWOOD, SONY MUSIC, COLUMBIA, GEFFEN,
AND INTERSCOPE RECORDS. SHE RECEIVED
HER DEGREE FROM ART CENTER COLLEGE
OF DESIGN IN PASADENA,
AND LIVES IN LOS ANGELES.

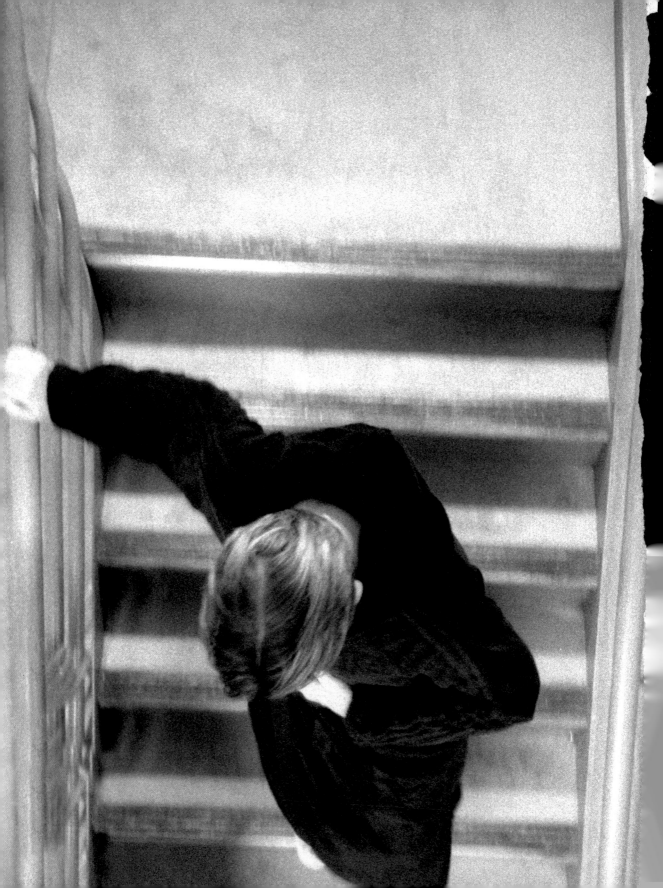